A
A
D

Art Architecture Design

PARIS

edited by Nathalie Grolimund

teNeues

Intro ART	8	Fondation Cartier		Musée d'Art Moderne	
Cinémathèque Française	10	pour l'Art Contemporain	32	de la Ville de Paris	46
Grand Palais	14	Portrait – César	34	Palais de Tokyo	48
Hôtel Biron – Musée Rodin	18	Galerie Besseiche Lartigue	36		
Musée du Quai Branly	22	Cité de l'Architecture			
Centre Pompidou	24	et du Patrimoine	38		
Galerie Celal	26	Guimet – Musée National			
Musée du Louvre	30	des Arts Asiatiques	42		

Intro ARCHITECTURE	50	Passerelle		Tour T1	88
Fondation Le Corbusier	54	Simone de Beauvoir	72	Cité de la Musique	92
Résidence Universitaire de Croisset	58	UGC Ciné Cité Bercy	76	Cité des Sciences	96
Opéra Bastille	60	Passage du Grand Cerf	78	Axa Private Equity	100
France Télévisions	64	Le Cube	80	Place du	
Parc André Citroën	66	Cœur Défense	82	Marché Saint-Honoré	102
Centre de Biotechnologies Biopark	70	La Grande Arche	84	Pyramide du Louvre	104

Intro DESIGN	124	Café Étienne Marcel	142	C42 Citroën	162
Kube Hotel	126	Kong Bar Restaurant	144	Colette	166
Mama Shelter	130	Andy Wahloo	146	Hermès Rive Gauche	168
Hôtel Gabriel Paris Marais	132	Le Georges	148	Portrait – Rena Dumas	170
La Cantine du Faubourg	136	Le Saut du Loup	152	Aquarium de Paris –	
Makassar		La Maison Blanche	154	Cinéaqua	172
Lounge & Restaurant	138	Le Renard	156		
Oth Sombath	140	L'Atelier Renault	160		

Map	174	Service	181	Credits // Imprint	186

ART

ARCHITECTURE

Notre-Dame
de l'Arche d'Alliance 108
École de Commerce Advancia 110
Cinetic 112
Institut du Monde Arabe 114
Portrait – Jean Nouvel 118

DESIGN

PARIS

Content

Paris is globally recognized as a metropolis of the avant-garde, and its creative minds have set trends in design, fashion, art, and architecture. Its blend of savoir-vivre, glamour, trend-setting and romance has attracted visitors for centuries. Every area has its own personality and is filled with things worth seeing and experiencing. Alongside the trendy newcomers' galleries and designer restaurants, AAD Paris presents you with classics that have lost nothing of their fascination after decades or even centuries. Quite the opposite: the Louvre, Palais de Tokyo, Musée Rodin, and others have been stylishly updated by conscientious architects, maneuvering them gently into the 21st century. Meanwhile, impressive examples of modern architecture by Renzo Piano, Richard Rogers, Dietmar Feichtinger, Jean-Paul Viguier, Jean Nouvel, Denis Valode, and Jean Pistre already promise to add glamour to the Parisian skyline in the 22nd century.

Paris gilt weltweit als Metropole der Avantgarde, und seine Kreativen setzen Trends in Design, Mode, Kunst und Architektur. Die Mischung aus Savoir-vivre, Glamour, Trendsetting und Romantik hat seit Jahrhunderten eine besondere Anziehungskraft. Jeder Bezirk hat seinen eigenen Charakter und ist reich an Sehens- und Erlebenswertem. Neben angesagten Newcomer-Galerien und Design-Restaurants präsentiert AAD Paris Klassiker, die selbst nach Jahrzehnten oder gar Jahrhunderten nichts von ihrer Faszination verloren haben. Im Gegenteil: Umsichtige Architekten haben Louvre, Palais de Tokyo, Musée Rodin und Co. mit stilsicheren Renovierungen behutsam ins 21. Jahrhundert manövriert, und sehenswerte Beispiele moderner Architektur von Renzo Piano, Richard Rogers, Dietmar Feichtinger, Jean-Paul Viguier, Jean Nouvel sowie Denis Valode und Jean Pistre tragen schon heute das Versprechen in sich, auch im 22. Jahrhundert zum Glanz von Paris beizutragen.

Paris est considéré comme la métropole de l'avant-garde dans le monde entier et ses artistes fixent les tendances du design, de la mode, de l'art et l'architecture. Depuis des siècles, Paris attire les visiteurs pour son savoir-vivre, son côté glamour, romantique et tendance. Chaque arrondissement a son charme et présente diverses curiosités qui valent le détour. En plus des galeries modernes et restaurants design, AAD Paris vous fait découvrir des grands classiques parisiens, qui depuis des décennies et même des siècles,

n'ont perdu de leur attrait irrésistible. Au contraire, des architectes ont œuvré avec discernement et style à la rénovation du Louvre, Palais de Tokyo, Musée Rodin et autres pour qu'ils continuent de briller au XXIᵉ siècle. Et les œuvres de Renzo Piano, Richard Rogers, Dietmar Feichtinger, Jean-Paul Viguier, Jean Nouvel ainsi que Denis Valode et Jean Pistre sont des exemples d'architecture moderne qui contribueront à maintenir l'éclat de la capitale au XXIIᵉ siècle.

La metrópoli parisina es epicentro de vanguardias, y las mentes creativas que la pueblan marcan tendencias en el diseño, la moda, el arte y la arquitectura. El crisol de savoir vivre, glamour, tendencias y romanticismo a orillas del Sena ejerce desde hace siglos un atractivo irresistible. Cada distrito tiene un carácter propio y alberga una infinidad de detalles por descubrir. AAD Paris presenta no sólo galerías de los más destacados artistas noveles del momento y restaurantes de diseño, sino también clásicos que no han perdido un ápice de su atractivo tras décadas, incluso siglos en funcionamiento. Muy al contrario: el buen hacer de los arquitectos ha conseguido adaptar el Louvre, el Palais de Tokyo, el museo Rodin y muchos otros espacios al siglo XXI, y son numerosos los ejemplos de arquitectura moderna (obra de Renzo Piano, Richard Rogers, Dietmar Feichtinger, Jean-Paul Viguier, Jean Nouvel, Denis Valode y Jean Pistre) que encierran en sí la promesa de contribuir a mantener el esplendor de París en el siglo XXII.

ART

A

Paris is art. This city's most beautiful works of art mutually influence each another. Design, fashion, painting, music, architecture, and more—all disciplines are constantly exchanging inspiration, while temples of art display artistic and architectural masterpieces, such as the Centre Pompidou by Renzo Piano and Richard Rogers, the Museum on quai Branly by Jean Nouvel, or the building of Cinémathèque française by Frank O. Gehry. The buildings of the Grand Palais and the Palais de Tokyo are also already renowned for their magnificence. Paris is constantly evolving. Artists and galleries create spaces and cultivate their reputations as globally leading centers of contemporary art. Works of modern art, graffiti art, and street art can be found in the Galerie Celal and Galerie Besseiche Lartigue. Yet among all this avant-garde and modernity, Paris will never forget the rich cultural heritage that has made the city what it is today: the holder of such beautiful works of art.

Paris ist Kunst. In dieser Stadt beeinflussen sich die schönen Künste gegenseitig. Design, Mode, Malerei, Musik, Architektur, etc. – alle Disziplinen stehen in einem ständigen Inspirationsaustausch, und die Tempel für die Kunst stellen selbst künstlerische und architektonische Meisterwerke dar, wie das Centre Pompidou von Renzo Piano und Richard Rogers, das Musée du quai Branly von Jean Nouvel oder das Gebäude der Cinémathèque française von Frank O. Gehry. Grandios sind auch die schon ehrwürdigen Bauten des Grand Palais oder des Palais de Tokyo. Paris ist im ständigen Wandel begriffen. Künstler und Galerien schaffen sich ihre Räume und kultivieren ihren Ruf als weltweit führende Metropole für zeitgenössische Kunst. Arbeiten moderner Kunst, Graffiti-Art und Streetart findet man in der Galerie Celal und der Galerie Besseiche Lartigue. Bei aller Avantgarde und Modernität vergisst Paris niemals sein reichhaltiges kulturelles Erbe, das die Stadt zu dem gemacht hat, was sie heute ist: die Stadt der schönen Künste.

Paris est un art à lui seul. Dans cette ville, les beaux-arts s'influencent mutuellement. Le design, la mode, la peinture, la musique, l'architecture etc. – toutes les disciplines s'articulent autour d'un courant d'inspiration commun et les temples de l'art présentent eux-mêmes des chefs d'œuvres artistiques et architecturaux comme le Centre Pompidou de Renzo Piano et Richard Rogers, le Musée du quai Branly de Jean Nouvel ou l'édifice de la Cinémathèque française de Frank O. Gehry. N'oublions pas les vénérables édifices comme le Grand Palais ou le Palais de Tokyo. Paris vit un perpétuel renouvellement. Artistes et galeries contribuent à sa réputation mondiale de métropole de l'art contemporain. Dans les galeries Celal et Besseiche Lartigue, on peut admirer des œuvres d'art moderne, d'art graffiti et d'art urbain. Malgré cet élan d'avant-garde et de modernité, Paris conserve l'empreinte de son passé et c'est ce qui fait d'elle aujourd'hui la ville des beaux-arts.

París es arte. La mutua influencia de las bellas artes es omnipresente en la ciudad. Diseño, moda, pintura, música, arquitectura... Todas las disciplinas participan en el constante intercambio de inspiraciones, y los propios templos de las artes son a su vez obras maestras de la arquitectura: buen ejemplo de ello son el Centre Pompidou de Renzo Piano y Richard Rogers, el Musée du quai Branly de Jean Nouvel y el edificio de la Cinémathèque française de Frank O. Gehry. No menos grandiosas son las venerables estructuras del Grand Palais o el Palais de Tokyo. París vive inmersa en el cambio incesante. Artistas y galerías crean espacios propios e incrementan el prestigio de París como foco principal del arte contemporáneo. Obras de arte moderno, graffiti y street art tienen cabida en la galería Celal y la galería Besseiche Lartigue. Pese a tanta vanguardia y modernidad, París no olvida su cuantiosa herencia cultural, responsable de que la ciudad sea, ahora y siempre, la ciudad de las bellas artes.

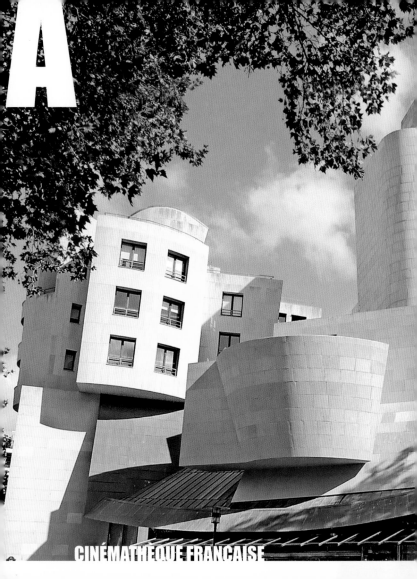

A

CINÉMATHÈQUE FRANÇAISE

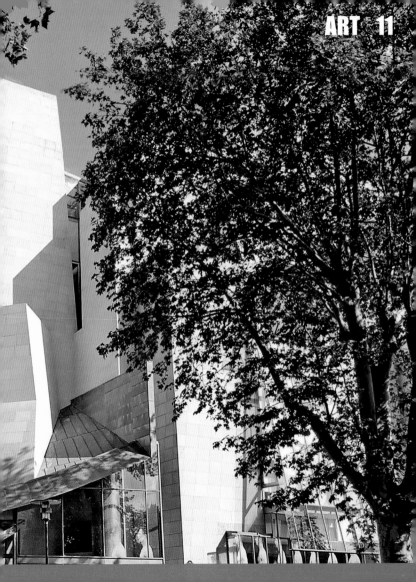

A

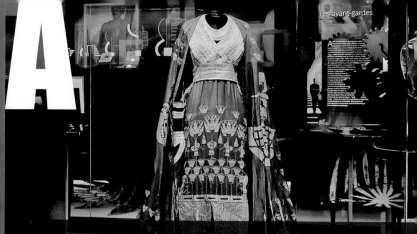

"The memory of cinema" as the French Film Institute Cinémathèque française is also known, enjoys role-model status for film preservation. The building, designed by Frank O. Gehry, originally contained the American Culture Institute, but since 2005 the deconstructivist edifice has been home to a collection of more than 40,000 films. The Parisian Atelier de l'Île has carefully integrated new archive rooms, a media library, and four movie theaters into Gehry's building.

„Das Gedächtnis des Kinos", wie das französische Filminstitut Cinémathèque française auch genannt wird, genießt weltweit Vorbildcharakter für den Erhalt der Filmkunst. Ursprünglich befand sich in dem von Frank O. Gehry entworfenen Gebäude das amerikanische Kulturinstitut. Seit 2005 beheimatet das dekonstruktivistische Bauwerk eine Sammlung von 40 000 Filmen. Behutsam integrierte das Pariser Atelier de l'Île neue Archivräume, eine Mediathek und vier Kinosäle in den Gehry-Bau.

« La mémoire du cinéma », nom aussi donné à la Cinémathèque française, bénéficie au niveau mondial du statut de modèle en matière de préservation de l'art cinématographique. À l'origine, le bâtiment déconstructiviste de Frank O. Gehry abritait le centre culturel américain. Depuis 2005, il abrite une collection de 40 000 films. Habilement, les architectes de l'Atelier de l'Île ont intégré des salles d'archive, une médiathèque et quatre salles de cinéma au bâtiment de Gehry.

"La memoria del cine", como ha dado en llamarse al instituto Cinémathèque française, trabaja de forma ejemplar en la conservación del séptimo arte. El deconstructivista edificio diseñado por Frank O. Gehry fue antes sede del instituto cultural norteamericano; desde 2005, sin embargo, alberga una colección de 40 000 películas. El parisino Atelier de l'Île ha incorporado respetuosamente nuevas salas de archivos, una medioteca y cuatro salas de proyecciones al edificio.

CINÉMATHÈQUE FRANÇAISE

51, rue de Bercy // Bercy
Tel.: +33 (0)1 71 19 33 33
www.cinematheque.fr

Mon–Sat noon to 7 pm, Sun 10 am to 8 pm
Closed on Jan 1st, May 1st, and Dec 25th
Métro Bercy

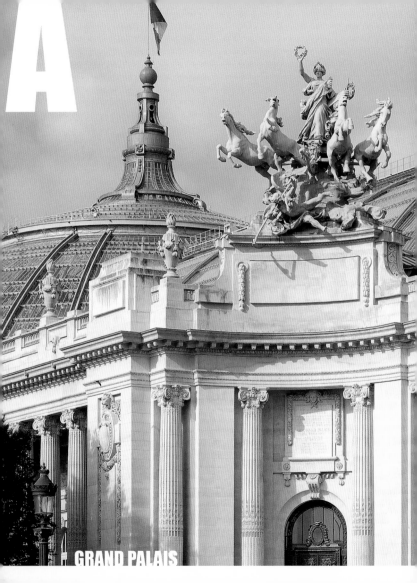

A

GRAND PALAIS

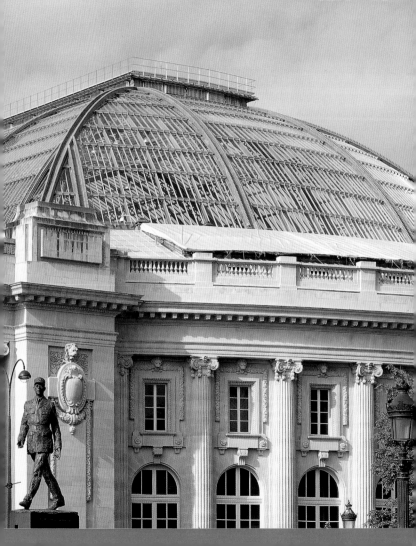

GRAND PALAIS

3, avenue du Général Eisenhower // Champs-Élysées
Tel.: +33 (0)1 44 13 17 17
www.grandpalais.fr

Daily 10 am to 8 pm, Wed 10 am to 10 pm
Métro Champs-Élysées / Clemenceau

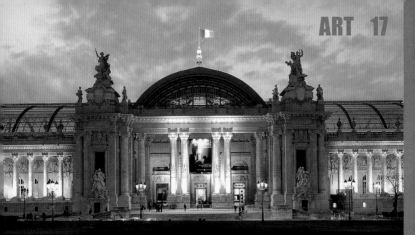

The Grand Palais exhibition hall, designed by architects Henri Deglane and Albert Louvet for the 1900 World Exhibition, lies between the Seine and the Champs-Élysées. With its iron, steel, and glass structured roof this is an impressive testimony to the innovative engineering of its day. Today the Grand Palais houses temporary exhibitions and the great Parisian FIAC art fair. The science museum Palais de la Découverte and its planetarium are located in the west wing.

Zwischen Seine und Champs-Élysées liegt die nach den Plänen der Architekten Henri Deglane und Albert Louvet zur Weltausstellung 1900 entworfene Ausstellungshalle Grand Palais. Mit seiner Dachkonstruktion aus Eisen, Stahl und Glas ist es ein beeindruckendes Zeugnis innovativer Ingenieurskunst seiner Zeit. Im Grand Palais finden heute Wechselausstellungen und die wichtige Pariser Kunstmesse FIAC statt. Im Westflügel befindet sich das Wissenschaftsmuseum Palais de la Dècouverte mit Planetarium.

Entre la Seine et les Champs-Élysées, se trouve le Grand Palais, construit à l'occasion de l'Exposition Universelle de 1900 d'après les plans des architectes Henri Deglane et Albert Louvet. Sa toiture mélangeant fer, acier et verre est un témoignage impressionnant du savoir-faire de l'époque. Le Grand Palais accueille de nombreuses expositions itinérantes ainsi que la Foire Internationale d'Art Contemporain (FIAC). L'aile ouest abrite le Palais de la découverte et son planétarium.

Entre el Sena y los Campos Elíseos se alza el Grand Palais, creado por los arquitectos Henri Deglane y Albert Louvet con ocasión de la Exposición Universal de 1900. El entramado del techo, combinación de hierro, acero y vidrio, es una muestra impresionante de la innovación técnica de la época. El Grand Palais acoge hoy diversas exposiciones y por supuesto la feria de arte FIAC. El ala oeste alberga el Palais de la Dècouverte, museo de la ciencia y planetario.

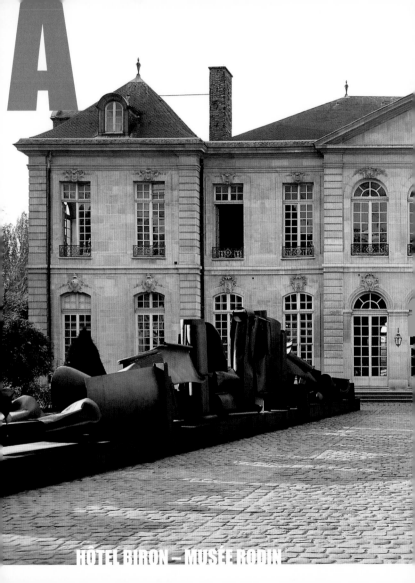

HÔTEL BIRON – MUSÉE RODIN

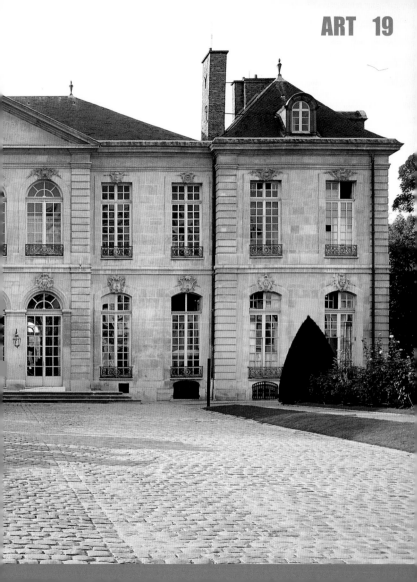

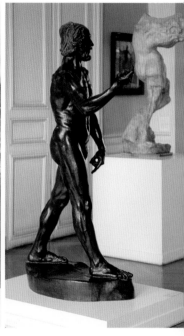

HÔTEL BIRON – MUSÉE RODIN

79, rue de Varenne // Invalides
Tel.: +33 (0)1 44 18 61 10
www.musee-rodin.fr

Tue–Sun 10 am to 5.45 pm
Métro Varenne

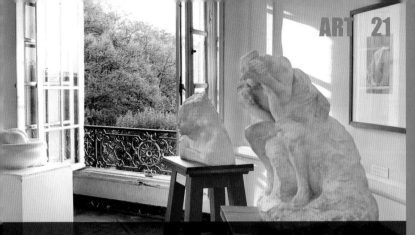

This elegant Rococo mansion was the workshop and residence of Auguste Rodin from 1908 until he died in 1917. In 1914, in exchange for the right to stay at the Hôtel Biron until his death, he willed his possessions to the French State on the condition that they create a museum there dedicated to his works. Since 1919, the mansion and its beautiful gardens have displayed sculptures by Rodin and his student and lover, Camille Claudel, including "The Kiss" and "The Gates of Hell," as well as objects of his private property.

Das Rokoko-Palais war von 1908 bis zu seinem Tode 1917 Atelier und Wohnung Auguste Rodins. Um Wohnrecht auf Lebenszeit zu erhalten, vermachte er 1914 seinen Nachlass dem Staat, mit der Auflage, in dem Palais ein Museum für seine Werke einzurichten. Seit 1919 werden im Palais und dem hübschen Garten die Skulpturen Rodins und seiner Schülerin und Geliebten Camille Claudel gezeigt, darunter „Der Kuss" und „Das Höllentor", ergänzt durch Gegenstände aus Rodins Privatbesitz.

Cet élégant palais rococo abritait entre 1908 et 1917, date de son décès, l'atelier et le domicile d'Auguste Rodin. Pour s'assurer un droit de logement à vie, il légua son bien en 1914 à l'État à condition que celui-ci le transforme en musée dédié à ses œuvres. Depuis 1919, le palais et l'adorable jardin attenant abritent des sculptures de Rodin et de son élève et bien-aimée, Camille Claudel, dont « le Baiser » et « la Porte de l'Enfer » et des pièces de sa collection privée.

Este elegante palacio rococó fue entre 1908 y 1917 (año de su muerte) taller y residencia de Auguste Rodin. Para asegurarse el derecho a residir allí de por vida, en 1914 Rodin legó su herencia al estado, a condición de que en el edificio se instituyese un museo dedicado a su obra. Desde 1919, en el palacio y los hermosos jardines se exponen las obras de Rodin y de su discípula y amante Camille Claudel, entre ellas "El beso" y "Las puertas del infierno", así como objetos personales de Rodin.

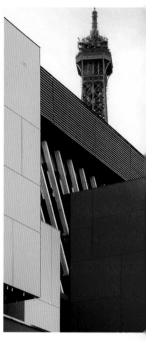

MUSÉE DU QUAI BRANLY

37, quai Branly // Invalides
Tel.: +33 (0)1 56 61 70 00
www.quaibranly.fr

Tue, Wed, Sun 11 am to 7 pm
Thu, Fri, Sat 11 am to 9 pm
Métro Bir Hakeim or Alma / Marceau

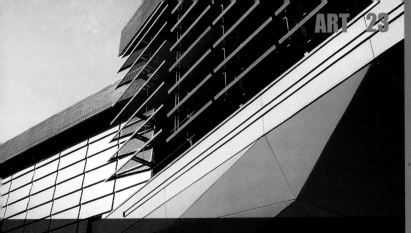

Designed by Jean Nouvel and opened in 2006, this museum of ethnology is dedicated to the dialog between cultures. The 3,500 objects on display showcase the arts and civilizations of Africa, Oceania, Asia, and the Americas. Special exhibitions, dance and music presentations, talks, workshops, and a multimedia library give visitors the opportunity to experience indigenous cultures up-close. Designed by Gilles Clément, the garden surrounding the museum adds to the exotic atmosphere.

Jean Nouvel entwarf das 2006 eingeweihte Völkerkundemuseum der Superlative. Dem Dialog der Kulturen gewidmet, sind die Kunst und Zivilisation Afrikas, Ozeaniens, Asiens und Amerikas anhand von 3 500 Exponaten, die durch Themenausstellungen, Tanz- und Musikdarbietungen, Vorträge, Workshops und eine Mediathek ergänzt werden, umfassend erfahrbar. Ein von Gilles Clément gestalteter, das Museum umgebender Garten verleiht dem Besuch den Charme einer Reise in exotische Länder.

Cet édifice conçu par Jean Nouvel et inauguré en 2006 est le summum des musées d'ethnologie. Consacré au dialogue des cultures, le musée présente une collection de 3 500 œuvres d'art d'Afrique, d'Océanie, d'Asie et d'Amérique, complétée par des expositions à thèmes, spectacles de danse et musique, conférences, séminaires et une médiathèque. Le jardin attenant esquissé par Gilles Clément vous transporte dans un monde au charme exotique.

El edificio diseñado por Jean Nouvel e inaugurado en 2006 es un extraordinario museo etnológico consagrado al diálogo intercultural que acerca al público el arte y la civilización de África, Oceanía, Asia y las Américas a través de 3 500 piezas de exposición, complementadas con muestras temáticas, eventos de danza y música, conferencias, talleres y una mediateca. El jardín que rodea el museo, obra de Gilles Clément, presta a la visita el encanto de un viaje a tierras exóticas.

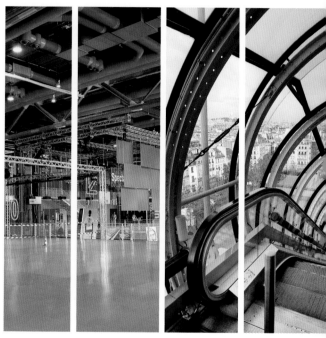

CENTRE POMPIDOU

Place Georges Pompidou // Le Marais
Tel.: +33 (0)1 44 78 12 33
www.centrepompidou.fr

Mon, Wed–Sun 11 am to 9 pm
Métro Rambuteau

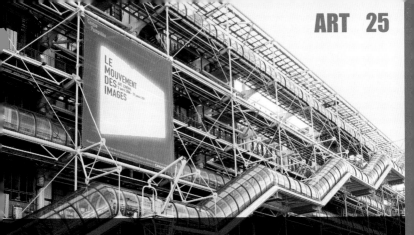

This center for modern art, designed by Renzo Piano and Richard Rogers, opened in 1977. Building elements such as a steel frame, escalators, and heating pipes were placed on the exterior, creating a pivotal work of postmodern architecture. In addition to Europe's largest collection of the masters of fauvism, cubism, surrealism, and pop art, the Centre Pompidou stages film, theater, design, and architecture events as well as temporary exhibtions.

1977 bauten Renzo Piano und Richard Rogers das Zentrum für moderne Kunst. Technische Elemente wie Stahlgerüst, Rolltreppen oder Heizungsrohre verlegten sie an die Außenfassaden und schufen damit ein Schlüsselwerk der Postmoderne. Neben Europas größter Sammlung der Meister des Fauvismus, Kubismus, Surrealismus und der Pop-Art stellen Film-, Theater-, Design- und Architekturevents sowie temporäre Ausstellungen die Highlights dar.

Ce centre d'art moderne fut construit en 1977 par les architectes Renzo Piano et Richard Rogers. Il est devenu un bâtiment clé du postmodernisme grâce à sa façade originale composée d'une charpente d'acier, d'escalators, de conduits de chauffage et ventilateurs. De plus, il abrite la plus grande collection de fauvisme, cubisme, surréalisme et pop art en Europe et propose des événements relatifs au cinéma, théâtre, design et à l'architecture ainsi que des expositions temporaires.

En 1977, Renzo Piano y Richard Rogers erigieron este centro de arte moderno: al trasladar a la fachada los elementos técnicos del edificio (estructura de acero, escaleras mecánicas, ventiladores...) crearon un puntal de la postmodernidad. Además de albergar la mayor colección europea de los maestros del fauvismo, cubismo, surrealismo y pop art, tienen en él cabida el cine, el teatro, el diseño y la arquitectura, así como exposiciones temporales.

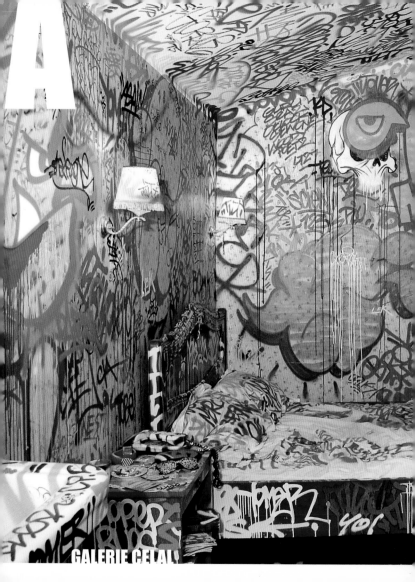

A

GALERIE CELAL

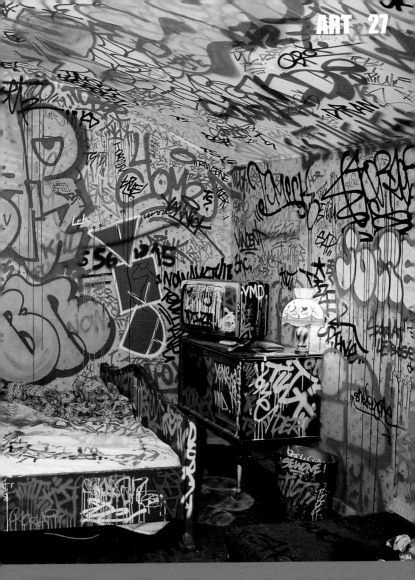

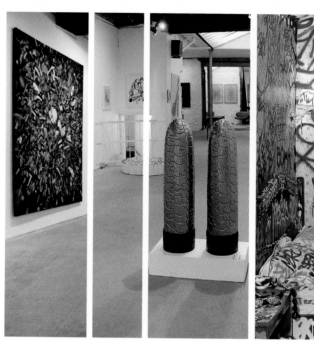

GALERIE CELAL

45, rue Saint-Honoré // Les Halles
Tel.: +33 (0)1 40 26 56 35
www.galeriecelal.com

Daily 2 pm to 7 pm
Métro Châtelet or Louvre / Rivoli

The appeal of Galerie Celal comes not just from its contemporary art programs, but also from its location in a former monastic building from the 16th century, between Centre Pompidou and Musée du Louvre. The gallery's main aim is to promote the work of young artists. Its light rooms, with limed or bare brick walls and cement flooring, are an additional tool for the artists, with which they can set the scene for their works.

Der Reiz der Galerie Celal liegt nicht nur in ihrem Programm zeitgenössischer Kunst, sondern auch in ihrer Lage: in einem ehemaligen Klostergebäude aus dem 16. Jahrhundert zwischen Centre Pompidou und Musée du Louvre. Die Galerie möchte besonders die Arbeit junger Künstler fördern. Die hellen Räume mit ihren nackten Mauern oder gekalkten Wänden und der Zementboden sind für die Künstler wie ein zusätzliches Werkzeug, mit dem sie ihre Kunst in Szene setzen.

Le charme de la galerie Celal réside non seulement dans sa collection d'œuvres d'art contemporain, mais également dans son décor : un ancien couvent du XVIe siècle situé entre le Centre Pompidou et le Musée du Louvre. La galerie souhaite tout particulièrement encourager le travail de jeunes artistes. Les salles lumineuses arborant des murs de briques ou enduits de chaux et un sol en béton constituent un outil supplémentaire pour les artistes dans leurs mises en scènes artistiques.

El atractivo de la galería Celal reside no sólo en su programación de arte contemporáneo, sino también en su ubicación, un antiguo convento del siglo XVI a medio camino entre el Centro Pompidou y el museo del Louvre. La galería trabaja especialmente en la promoción de jóvenes artistas. Las salas, encaladas o de ladrillo visto, así como el suelo de cemento, son para los artistas una herramienta adicional para la puesta en escena de sus creaciones.

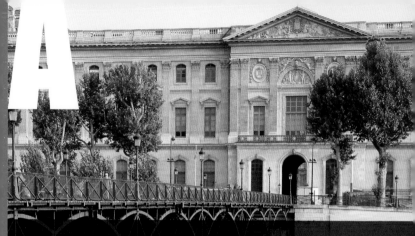

A

The Louvre is one of the most beautiful and largest museums in the world. Only 8% of its holdings, dating from antiquity to 1848 and spanning all major art epochs and regions, are on display, including popular attractions such as the "Venus de Milo" and the "Mona Lisa." Expansive restorations have updated the style of presentation, and works by contemporary artists have been added. For example, a painting by Cy Twombly on the ceiling of the Bronze Room was unveiled in 2010.

Er gilt als eines der schönsten und größten Museen der Welt. Gerade 8 % des Bestandes, der von der Antike bis 1848 reicht und alle wichtigen Kunstepochen und -regionen umfasst, sind ausgestellt. Darunter Publikumsmagnete wie die „Venus von Milo" oder die „Mona Lisa". Aufwendige Restaurierungen ermöglichen eine zeitgemäße museale Präsentation, und die Werke zeitgenössischer Künstler hielten Einzug: so schmückt seit 2010 ein Gemälde Cy Twomblys den Bronzesaal der Antike.

Le Louvre compte parmi les plus beaux et grands musées du monde. Seulement 8 % des œuvres de l'Antiquité à 1848 et des époques et régions artistiques les plus importantes sont exposées. La « Vénus de Milo » et la « Mona Lisa » constituent des aimants touristiques. Les restaurations des dernières années apportèrent un vent nouveau et les œuvres d'artistes contemporains firent leur entrée. Depuis 2010, une peinture de Cy Twombly est exposée dans la salle des Bronzes antiques.

Qué decir del que sin duda es uno de los mayores y más hermosos museos del mundo. En él se expone apenas un 8 % de la colección total, que abarca desde la Antigüedad hasta 1848 e incluye piezas tan conocidas como la "Venus de Milo" y la "Mona Lisa". Las extensas restauraciones acometidas en los últimos años han modernizado el museo y permiten la presencia de artistas contemporáneos en sus salas: desde 2010, un cuadro de Cy Twombly adorna la sala de bronces de la Antigüedad.

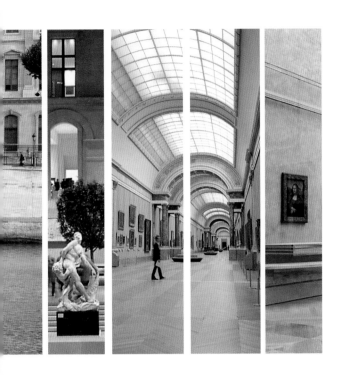

MUSÉE DU LOUVRE

Musée du Louvre // Louvre
Tel.: +33 (0)1 40 20 53 17
www.louvre.fr

Wed–Mon 9 am to 6 pm, Wed and Fri 9 am to 10 pm
Closed on Jan 1st, May 1st, and Dec 25th
Every first Sun of the month and Jul 14th free access
Métro Palais Royal / Musée du Louvre

Since 1984, jeweler Cartier has been a sponsor of international avant-garde art. The Foundation, first proposed by sculptor César, resides in a glass building designed by Jean Nouvel and completed in 1994. It dematerializes its architecture and eliminates the boundaries between inside and outside. Exhibitions focus on contemporary paintings, photography, sculptures, pop culture, and video art, and show not only stars like Matthew Barney but also emerging artists.

Seit 1984 fördert das Unternehmen Cartier als Mäzen internationale Avantgardekunst. Die auf Anregung des Künstlers César ins Leben gerufene Fondation residiert in einem 1994 von Jean Nouvel erbauten Glaspalast, der die Architektur entmaterialisiert und die Grenzen zwischen Innen und Außen aufhebt. Wechselausstellungen sind zeitgenössischen Werken der Malerei, Fotokunst, Skulptur, Pop-Kultur und Videokunst gewidmet und präsentieren Stars der Szene wie Matthew Barney und Newcomer.

Cette fondation sponsorise depuis 1984 l'art international avant-gardiste. Créée à l'instigation de l'artiste César, elle réside dans un palais de glace, construit en 1994 par Jean Nouvel, qui dématérialisa l'architecture et repoussa les frontières entre l'intérieur et l'extérieur. Des expositions temporaires d'art contemporain dont la peinture, la photographie, la sculpture, la culture pop et l'art vidéo, présentent des stars de renom comme Matthew Barney et des jeunes artistes.

La empresa Cartier fomenta desde 1984 el arte internacional de vanguardia. La fundación, creada a propuesta del artista César, tiene su sede en un palacio de cristal diseñado en 1994 por Jean Nouvel, en el que la arquitectura se desmaterializa y el concepto de interior y exterior se desdibuja. Las exposiciones, dedicadas al arte contemporáneo en todas sus facetas, han visto ya pasar por sus salas a estrellas consagradas como Matthew Barney y a diversos talentos noveles.

FONDATION CARTIER
POUR L'ART CONTEMPORAIN

261, boulevard Raspail // Saint-Germain-des-Prés
Tel.: +33 (0)1 42 18 56 50
www.fondation.cartier.com

Tue–Sun 11 am to 8 pm, Tue 11 am to 10 pm
Closed on Jan 1st and Dec 25th
Métro Raspail

CÉSAR

Once a year the French film industry sends out invitations to its César awards, where winners are presented a work of a renowned sculptor. César Baldaccini—his full name—grew up in Marseille where he attended the École des Beaux-Arts before continuing studies in Paris from 1943. Here he got to know Giacometti, Brâncuși, and Picasso, who would permanently influence his work. When he died age 77 in Paris in 1998, he was one of the most prominent representatives of the Nouveau Réalisme artists' society, a star of the art scene. César was master of matter. He meshed heavy structures from everyday objects with artistic means of expression in extreme compressions and expansions. His initiatives were partly to thank for the decision of Cartier International director Alain Dominique Perrin to found the Center for Contemporary Art. In 2008, ten years after César's death, his friend Jean Nouvel launched a critically acclaimed retrospective containing works of glass architecture from 1994 for the Parisian Fondation Cartier.

Wenn die französische Filmindustrie einmal im Jahr zur Verleihung des Césars einlädt, dann halten die besten Schauspieler ein Werk des berühmten Bildhauers César in Händen. César Baldaccini, wie er mit bürgerlichem Namen hieß, wuchs in Marseille auf, wo er bereits die École des Beaux-Arts besuchte, bevor er ab 1943 in Paris seine Studien fortsetzte. Hier lernte er Giacometti, Brâncuși und Picasso kennen, die sein Schaffen nachhaltig prägten. Als er 1998 im Alter von 77 Jahren in Paris starb, war er einer der prominentesten Vertreter der Künstlervereinigung Nouveau Réalisme und ein Star der Kunstszene. César galt als Meister der Materie. Tonnenschwere Gebilde aus Resten der Alltagskultur verzahnte er mit künstlerischen Ausdrucksmitteln in Form von extremen Kompressionen und Expansionen. Nicht zuletzt seiner Initiative ist es zu verdanken, dass der Direktor von Cartier International, Alain Dominique Perrin, das Zentrum für zeitgenössische Kunst gründete. 2008, zehn Jahre nach Césars Tod, konzipierte sein Freund Jean Nouvel eine viel beachtete Retrospektive in der von ihm 1994 neu erbauten Glasarchitektur der Pariser Fondation Cartier.

Les Césars remis aux meilleurs acteurs lors de la cérémonie des Césars, organisée chaque année par l'industrie du film français, ne sont autre que des œuvres de César, le sculpteur renommé. César, de son nom civil César Baldaccini, grandit à Marseille où il fréquenta l'École des Beaux-Arts jusqu'en 1943, avant de continuer ses études à Paris. C'est alors qu'il fit la connaissance de Brâncuși et Picasso qui influencèrent considérablement ses travaux. Quand il mourut à Paris en 1998 à l'âge de 77 ans, il était alors considéré comme le représentant éminent du groupe des Nouveaux Réalistes et une vedette de la scène artistique. César était le maître de la matière par excellence. Il soumettait des objets du quotidien à un processus de compression et d'expansion et les transformait en sculptures de plusieurs tonnes. C'est notamment grâce à son initiative artistique que le directeur de Cartier International, Alain Dominique Perrin, fonda le Centre d'Art Contemporain. En 2008, dix ans après sa mort, son ami Jean Nouvel lui dédia une rétrospective détaillée dans l'enceinte de l'architecture de verre de la Fondation Cartier qu'il rénova en 1994.

Cuando la industria cinematográfica se reúne cada año en la ceremonia de entrega de los premios César, los actores galardonados levantan en sus manos una pieza del famoso escultor César. César Baldaccini (tal era su nombre completo) creció en Marsella, donde fue alumno de la École des Beaux-Arts hasta que en 1943 se trasladó a París para continuar sus estudios. Allí conoció a Giacometti, Brâncuși y Picasso, artistas todos que tendrían una influencia duradera sobre su creación. A su muerte, acontecida en 1998 a la edad de 77 años, era ya uno de los más destacados representantes del Nuevo Realismo y una estrella en el mundillo artístico. César está considerado un maestro de los materiales: sobre la base de enormes y pesados restos de la cultura cotidiana engarzaba medios artísticos de expresión en forma de compresiones y expansiones extremas. A su iniciativa se debe en buena medida que Alain Dominique Perrin, a la sazón director de Cartier International, fundase el Centro de Arte Contemporáneo. En 2008, diez años después de la muerte de César, la retrospectiva organizada por su amigo Jean Nouvel en el marco acristalado de la Fondation Cartier (obra del propio Nouvel) recibió una extraordinaria acogida.

GALERIE BESSEICHE LARTIGUE

33, rue Guénégaud // Saint-Germain-des-Prés
Tel.: +33 (0)1 40 46 08 08
www.artcontemporaingalerie.com

Tue–Sat 11 am to 7 pm
Métro Odéon

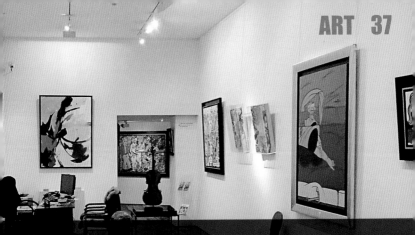

Galerie Besseiche Lartigue specializes in 20th century art. Its program includes cubism, surrealism, abstract art, and pop art, and visitors can see and buy for example works by Adami Valerio, Salvador Dalí, Yves Klein, Andy Warhol, and Tom Wesselmann. Presentation of the artwork is of the utmost importance in this gallery, as can be seen from the varied and often extravagant interiors by the artist Oscar Larrat.

Die Galerie Besseiche Lartigue hat sich auf die Kunst des 20. Jahrhunderts spezialisiert. So gehören unter anderem Kubismus, Surrealismus, abstrakte Kunst oder Pop-Art zum Programm, und Besucher können Werke von Adami Valerio, Salvador Dalí, Yves Klein und Andy Warhol bis hin zu Tom Wesselmann betrachten und kaufen. Dass die Galerie sehr viel Wert auf die Präsentation der Kunstwerke legt, zeigt das wechselnde und oftmals extravagante Interieur des Künstlers Oscar Larrat.

La Galerie Besseiche Lartigue est spécialisée dans l'art du XXᵉ siècle. Les visiteurs peuvent y admirer et acheter des œuvres de cubisme, surréalisme, d'art abstrait ou de pop art dont celles d'artistes renommés comme Adami Valerio, Salvador Dalí, Yves Klein, Andy Warhol et Tom Wesselmann. Le décor extravagant et souvent changeant, orchestré par l'artiste Oscar Larrat, démontre l'importance que la galerie accorde à la présentation de ses œuvres.

La galería Besseiche Lartigue se especializa en arte del siglo XX. El cubismo, el surrealismo, el arte abstracto y el pop art son tendencias habituales en su programación, y los asistentes a las exposiciones pueden admirar y adquirir obras de artistas tan diversos como Adami Valerio, Salvador Dalí, Yves Klein, Andy Warhol y Tom Wesselmann. La importancia que la galería concede a la presentación de las obras queda reflejada en el extravagante interiorismo, obra del artista Oscar Larrat.

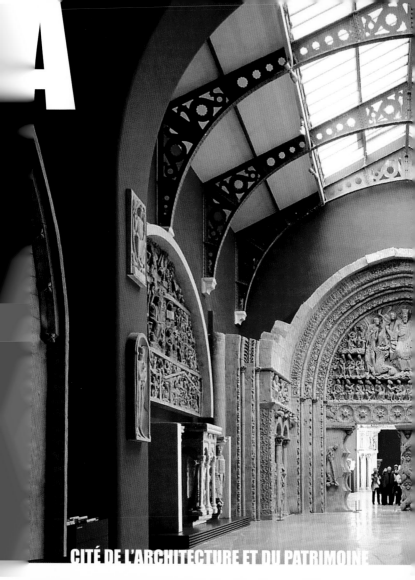

A

CITÉ DE L'ARCHITECTURE ET DU PATRIMOINE

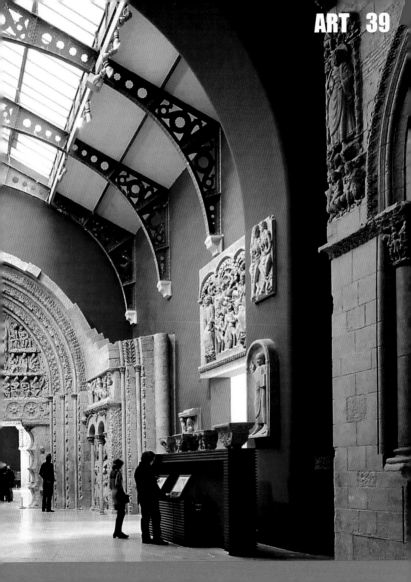

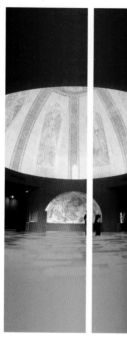

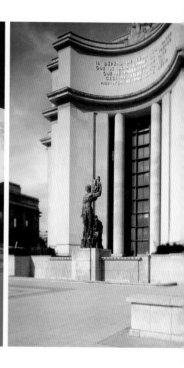

CITÉ DE L'ARCHITECTURE
ET DU PATRIMOINE

1, place du Trocadéro // Trocadéro
Tel.: +33 (0)1 58 51 52 00
www.citechaillot.fr

Mon, Wed, Fri, Sat, Sun 11 am to 7 pm, Thu 11 am to 9 pm
Closed on Jan 1st, May 1st, and Dec 25th
Métro Trocadéro

ART

Near the Eiffel Tower, the Palais de Chaillot, built in 1937 in the neoclassical style, houses an architecture museum that interprets architectural history from the Romanesque era to today. Life-size castings and copies of sculptures and murals allow visitors to compare masterpieces from different eras. Using models, maps, and photos, the Gallery of Modern Architecture documents architecture, city planning, and the challenges of modern urban development from 1850 until today.

In Sichtweite des Eiffelturms kann im 1937 errichteten neoklassizistischen Palais de Chaillot französische Architekturgeschichte von der Romanik bis heute studiert werden. Abgüsse und Kopien von Skulpturen und Wandmalerei in Originalgröße erlauben den direkten Stilvergleich von Kunstwerken unterschiedlicher Epochen. Die Galerie moderner Architektur dokumentiert mittels Modellen, Plänen und Fotografien die Architektur, Stadtplanung und Probleme moderner Urbanität von 1850 bis heute.

Près de la Tour Eiffel, ce palais de style néoclassique fut érigé en 1937. On y étudie l'histoire de l'architecture française à partir de la période romane. Moulages, copies de sculptures et peintures murales grandeur nature permettent au visiteur de comparer les œuvres issues de diverses époques. Modèles, plans et photographies sont répertoriés dans la galerie d'architecture moderne et illustrent l'architecture, l'urbanisme et les problèmes de l'urbanité de 1850 à nos jours.

En el neoclasicista Palais de Chaillot, erigido en 1937, es posible estudiar la historia de la arquitectura desde el románico hasta la actualidad con la Torre Eiffel como telón de fondo. Vaciados y copias de esculturas y murales a escala real permiten la comparación directa entre obras de distintas épocas. La galería de arquitectura moderna documenta con maquetas, planos y fotografías la arquitectura, planificación y problemática urbanística desde 1850 hasta nuestros días.

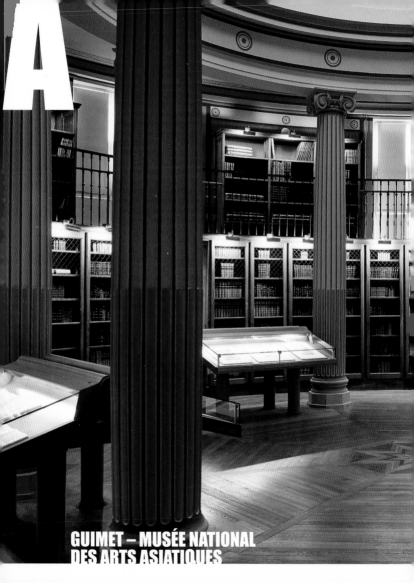

A

GUIMET – MUSÉE NATIONAL
DES ARTS ASIATIQUES

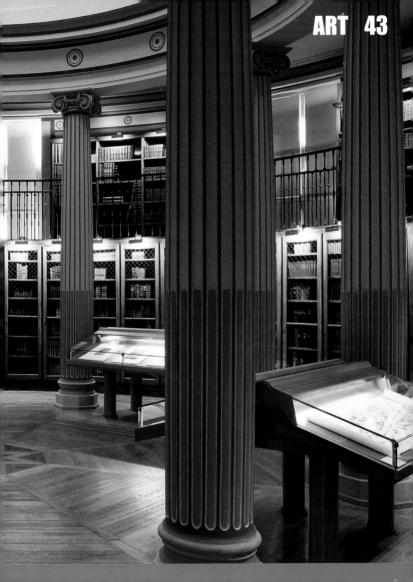

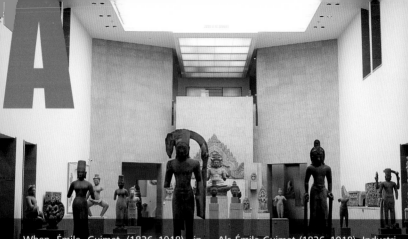

A

When Émile Guimet (1836–1918), industrialist and world traveler from Lyon, opened his museum in 1889, nobody could have anticipated that it would one day house the largest collection of Asian art outside of Asia. Continuously expanded through purchases and donations, the collection now showcases the art and culture of 17 Asian countries. The museum also includes the Buddhist Pantheon with its Japanese garden, a library, and a unique sound archive with more than 3,000 samples.

Als Émile Guimet (1836–1918), Industrieller und Fernreisender aus Lyon, 1889 das Museum eröffnete, ahnte niemand, dass damit der Grundstock für die einst größte Sammlung asiatischer Kunst außerhalb Asiens gelegt war. Durch Ankäufe und Schenkungen stetig erweitert, vereint es heute Kunst und Kultur aus 17 Ländern Asiens. Zu dem Museum gehören ferner das Buddhistische Pantheon mit japanischem Garten, eine Bibliothek und ein einzigartiges Tonarchiv mit über 3 000 Klangbeispielen.

Lors de son inauguration en 1889 à l'initiative d'Émile Guimet (1836–1918), industriel et grand voyageur lyonnais, personne ne se doutait qu'il abriterait une des plus grandes collections d'art asiatique hors d'Asie. Diverses acquisitions et dons élargirent la collection. Elle compte des œuvres de 17 pays asiatiques. Le musée est complété du Panthéon bouddhiste et son jardin japonais, la bibliothèque et la phonothèque où sont répertoriées plus de 3 000 archives sonores.

Cuando Émile Guimet (1836–1918), industrial y viajero lionés, inauguró el museo en 1889, nadie podía sospechar que se estaban sentando las bases de la mayor colección de arte asiático fuera de Asia. En constante ampliación gracias a adquisiciones y donaciones, actualmente acoge arte y cultura de 17 países asiáticos. El museo se completa con el Panteón Budista y su jardín japonés, una biblioteca y un archivo sonoro único en su género, con más de 3 000 grabaciones.

GUIMET – MUSÉE NATIONAL DES ARTS ASIATIQUES

6, place d'Iéna // Trocadéro
Tel.: +33 (0)1 56 52 53 00
www.guimet.fr

Wed–Mon 10 am to 6 pm
Métro Iéna

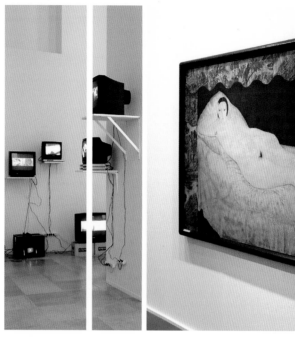

MUSÉE D'ART MODERNE
DE LA VILLE DE PARIS

11, avenue du Président Wilson // Trocadéro
Tel.: +33 (0)1 53 67 40 00
www.mam.paris.fr

Tue–Sun 10 am to 6 pm
Métro Iéna

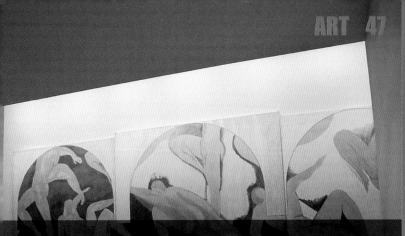

The roots of this collection of 20th century art go back to 1937. For the World's Fair, Raymond Escholier, curator of the Petit Palais, acquired several works of classic modernism, including pieces by Henri Matisse, Raoul Dufy, and Robert Delaunay. In 1961, the collection moved to the Palais de Tokyo. In addition to classic modernism, it focuses on the École de Paris and contemporary art, and also presents retrospectives of the great masters.

Der Beginn dieser Sammlung an Kunst des 20. Jahrhunderts reicht ins Jahr 1937 zurück. Anlässlich der Weltausstellung erwarb Raymond Escholier, Kurator des Petit Palais, mehrere Werke der Klassischen Moderne, darunter Arbeiten von Henri Matisse, Raoul Dufy und Robert Delaunay. 1961 kam die Sammlung in das Palais de Tokyo. Ihr Schwerpunkt liegt heute neben der Klassischen Moderne auf Werken der École de Paris und auf Gegenwartskunst. Retrospektiven großer Meister ergänzen die Schau.

Les prémices de cette collection d'art du XXe siècle remontent à 1937. À l'occasion de l'Exposition Universelle, Raymond Escholier, conservateur du Petit Palais, acquiert des œuvres de classique moderne dont d'Henri Matisse, Raoul Dufy et Robert Delaunay. La collection, transférée en 1961 au Palais de Tokyo, présente également des travaux de l'École de Paris et des œuvres d'art contemporain. Des rétrospectives de grands maîtres viennent étayer le programme.

Los inicios de esta destacada colección de arte del siglo XX se remontan a 1937. Con ocasión de la Exposición Universal, Raymond Escholier, conservador del Petit Palais, adquirió diversas obras de vanguardia, entre ellas varias de Henri Matisse, Raoul Dufy y Robert Delaunay. En 1961, la colección se trasladó al Palais de Tokyo, donde se exponen también obras de la École de Paris y de arte contemporáneo. La exposición se completa con retrospectivas de grandes maestros.

PALAIS DE TOKYO

13, avenue du Président Wilson // Trocadéro
Tel.: +33 (0)1 47 23 54 01
www.palaisdetokyo.com

Tue–Sun noon to 9 pm
Métro Iéna

Directed by architects Anne Lacation and Jean-Philippe Vassal, the 2001 interior redesign of this palais originally built for the World's Fair in 1937 has been one of the most innovative projects of the last decade, suggesting a laboratory for avant-garde art. Resembling a gigantic loft, open spaces juxtapose installations, paintings, and sculptures by emerging contemporary artists from France and other countries. Visitors can take a break at Restaurant Tokyo Eat.

Das von den Architekten Anne Lacation und Jean-Philippe Vassal 2001 umgebaute Interieur des für die Weltausstellung 1937 errichten Palais ist eines der innovativsten Projekte der letzten Jahre und gleicht einem Laboratorium für Avantgardekunst. Einem riesigen Loft vergleichbar, treten in offenen Räumen Installationen, Malereien und Skulpturen junger französischer und internationaler Gegenwartskünstler miteinander in Beziehung. Zum Verweilen lädt das Restaurant Tokyo Eat ein.

Érigé en 1937 pour l'Exposition Universelle, ce palais, réaménagé en 2001 par Anne Lacation et Jean-Philippe Vassal compte parmi les projets les plus novateurs des dernières années et constitue un laboratoire d'art avant-gardiste. Dans cet ensemble de salles ouvertes similaire à un loft se côtoient des installations, peintures et sculptures de jeunes talents français et artistes contemporains internationaux. Vous pourrez vous attarder un moment dans le restaurant Tokyo Eat.

El interiorismo acometido por Anne Lacation y Jean-Philippe Vassal en el edificio construido para la Exposición Universal de 1937 constituye uno de los proyectos más innovadores de los últimos años y puede parecer incluso un laboratorio de arte vanguardista. Muy similar a un inmenso loft, en sus salas abiertas se establece el diálogo entre las instalaciones, cuadros y esculturas de jóvenes artistas contemporáneos franceses y extranjeros. Para reponer fuerzas dispone del restaurante Tokyo Eat.

Paris is a capital city that is always trying out new visions and directions in urban development. In this cityscape, tradition and history prevail today as they did in the past. Parisian architectural monuments decorate millions of postcards and guidebooks, serving as an anchor to these images of a city with valuable cultural history. But Paris also has a different, more modern side. Panoramas have been marked by the greatest architects of today and their constructions just as the old masters Victor Baltard and Georges-Eugène Baron Haussmann did in their day. 20th century architects have experimented as if in a lab, and in this city, so richly bejeweled with avantgarde masterpieces, architecture lovers can pick and choose: the Grande Arche and the high-rise buildings in the business district La Défense, the Cité des Sciences, and the Institut du Monde Arabe are just some examples. Architecture is always on the move, especially in Paris.

Paris gehört zu den Großstädten, in denen immer schon Visionen und neue Wege des Städtebaus erprobt wurden. Das Traditionelle und Historische überwiegt nach wie vor das Stadtbild. Pariser Baudenkmäler zieren millionenfach Postkarten und Reiseführer und verankern das Bild einer Stadt mit einer wertvollen Kulturgeschichte. Paris hat aber auch diese ganz andere, moderne Seite. Die größten Architekten der Gegenwart prägen mit ihren Bauwerken ebenso das Panorama, wie es die alten Meister Victor Baltard oder Georges-Eugène Baron Haussmann zur ihrer Zeit taten. Wie in einem Experimentierlabor haben die Architekten die 20. Jahrhunderts einiges ausprobiert, und in der reich mit Meisterwerken der Avantgarde bestückten Stadt kann der Architekturliebhaber aus dem Vollen schöpfen: La Grande Arche und die Hochhäuser im Geschäftsviertel La Défense, die Cité des Sciences und das Institut du Monde Arabe sind nur einige Beispiele. Die Architektur ist immer in Bewegung – besonders in Paris.

En matière d'urbanisme, Paris a toujours été le théâtre de nouvelles visions et tendances architecturales. Pourtant, tradition et histoire continuent de dominer. Des millions de cartes postales et guides touristiques représentent des édifices historiques, ce qui démontre l'importante histoire culturelle dont la capitale est empreinte. Mais Paris a aussi un aspect moderne. Les plus grands architectes contemporains ont marqué la capitale de leurs œuvres, comme l'ont fait à leur époque de grands maîtres tels que Víctor Baltard ou le baron Georges-Eugène Haussmann. Comme dans un laboratoire, les architectes du XXᵉ siècle ont expérimenté de nouvelles tendances, émaillant ainsi la ville de nombreuses constructions avant-gardistes. Les amoureux d'architecture n'ont que l'embarras du choix : la Grand Arche et les gratte-ciels du quartier de La Défense, la Cité des Sciences et l'Institut du Monde Arabe sont quelques exemples parmi tant d'autres. L'architecture parisienne est en permanente évolution.

París es una de las grandes ciudades en las que se ha experimentado con nuevos modelos y conceptos urbanísticos. La tradición y la historia son aun hoy determinantes en la imagen de la ciudad: los edificios singulares de París decoran millones de postales y guías de viajes y vinculan la imagen de la ciudad con una riquísima historia cultural. Pero París tiene también otro rostro mucho más moderno: la aportación de los principales arquitectos de nuestra era al rostro de la ciudad es tan importante como lo fue en su día la de los maestros Victor Baltard o Georges-Eugène Barón Haussmann. Como si de un laboratorio se tratase, los arquitectos del siglo XX han realizado diversos experimentos en la ciudad y así, ante los amantes de la arquitectura se abre un amplísimo abanico de obras maestras de la construcción de vanguardia: La Grande Arche y los rascacielos del barrio de La Défense, la Cité des Sciences y el Institut du Monde Arabe, por citar sólo algunos ejemplos. La arquitectura está en continuo movimiento, especialmente en París.

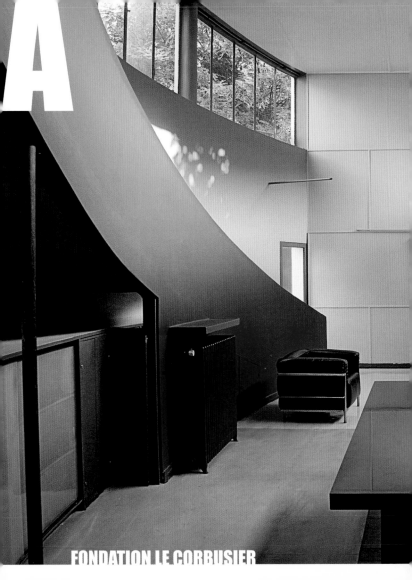

A

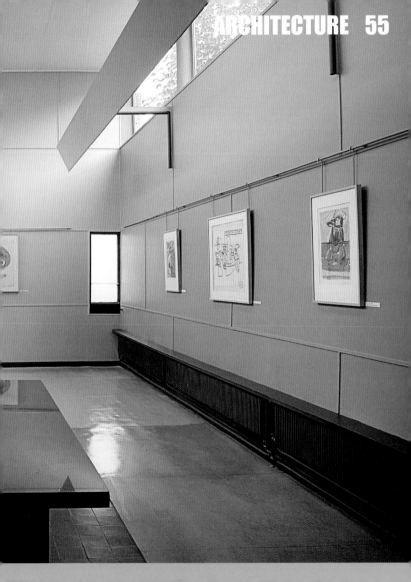

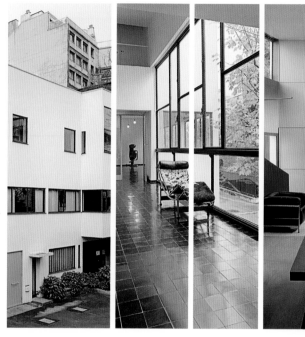

FONDATION LE CORBUSIER

8, square du Docteur Blanche // Auteuil
Tel.: +33 (0)1 42 88 41 53
www.fondationlecorbusier.fr

Mon 1.30 pm to 6 pm, Tue–Thu 10 am to 6 pm
Fri–Sat 10 am to 5 pm
Métro Jasmin

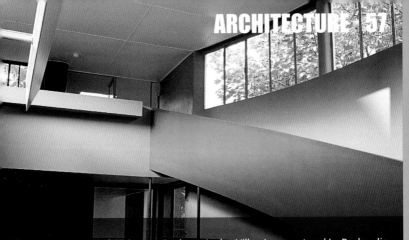

Maison Jeanneret and Maison La Roche, built by Le Corbusier in 1923, are now home to the Fondation Le Corbusier whose mission it is to preserve and promote his legacy. Not only can visitors explore Le Corbusier's groundbreaking architecture, perfectly documented in these two villas, but they can also admire the entire spectrum of his creative output: drawings, drafts, writings, furniture, and sculptures. A library and a photo archive round out the collection.

In den Villen Jeanneret und La Roche, die Le Corbusier 1923 erbaute, wacht die Fondation über seinen Nachlass und sorgt für dessen Erhalt und Verbreitung. Daher kann hier nicht nur die stilbildende Architektur Le Corbusiers, die in beiden Villen perfekt dokumentiert ist, sondern sein vielseitiges Gesamtœuvre bestaunt werden: Zeichnungen, Entwürfe, Schriften, Möbel und Skulpturen. Eine Bibliothek und eine Fotothek ergänzen die Sammlung.

La Fondation, située dans les villas Jeanneret et La Roche, construites en 1923 par Le Corbusier, pionnier de l'architecture moderne, veille sur son héritage et assure sa préservation et son expansion. Les deux villas présentent non seulement une architecture typiquement Le Corbusier, mais également l'intégralité de son œuvre : dessins, croquis, écritures, meubles et sculptures. Une bibliothèque et une photothèque complètent la collection.

En las villas Jeanneret y La Roche, construidas en 1923 por Le Corbusier, el gran pionero de la arquitectura moderna, la fundación que lleva su nombre vela por la conservación y promoción de su legado. Así, aquí se puede admirar no sólo el precursor estilo de Le Corbusier, perfectamente documentado en ambas villas, sino también el polifacético conjunto de su obra: dibujos, esbozos, textos, muebles y esculturas. La biblioteca y fototeca completan la colección.

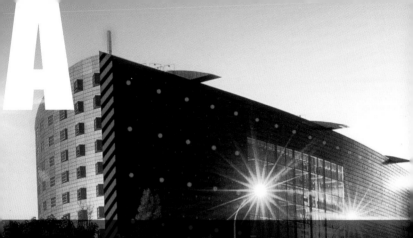

A

Designed to screen out the traffic noise from the Boulevard Périphérique, a curved wall of concrete with a giant window fronts three student housing towers. The three tapered 10-story buildings with their curved façades contain a total of 351 apartments in three different size configurations. Housing the administrative tract, a low-slung transverse base connects the four structures of this complex designed by AS. Architecture-Studio and completed in 1996.

Hinter einer gewölbten Betonwand, in die ein riesiges Sichtfeld eingelassen ist und die den Autolärm der Périphérique abschirmt, erheben sich drei Studentenwohnheime. Die drei spitz zulaufenden Bauten mit ihren gewölbten Fassaden bieten auf zehn Etagen Platz für insgesamt 351 Appartments in drei Größen. Ein niedriger, quer gelagerter Sockel, der als Verwaltungstrakt dient, verbindet die vier Baukörper des 1996 von AS. Architecture-Studio errichteten Komplexes.

Les trois résidences étudiantes sont protégées du bruit de la circulation sur le périphérique derrière un mur de béton, sur lequel s'ouvre une immense baie vitrée. Les trois tours effilées aux façades voûtées abritent 351 appartements de trois tailles différentes sur une surface de dix étages. Un socle inférieur transversal relie les quatre bâtiments de ce complexe, conçu en 1996 par le cabinet AS. Architecture-Studio, et abrite l'aile de l'administration.

Tres residencias universitarias se alzan tras un muro curvo de hormigón, sobre el que se abre un inmenso ventanal y que protege a los residentes del estruendo del tráfico en la vía de circunvalación. Los tres edificios ahusados de fachada curva acogen un total de 351 apartamentos de distintos tamaños en sus diez plantas. Un basamento transversal acoge las oficinas y une los cuatro elementos del complejo diseñado en 1996 por AS. Architecture-Studio.

RÉSIDENCE UNIVERSITAIRE DE CROISSET

4–8, rue Francis de Croisset // Barbes
Tel.: +33 (0)1 42 54 48 98
www.crous-paris.fr

Métro Porte de Clignancourt

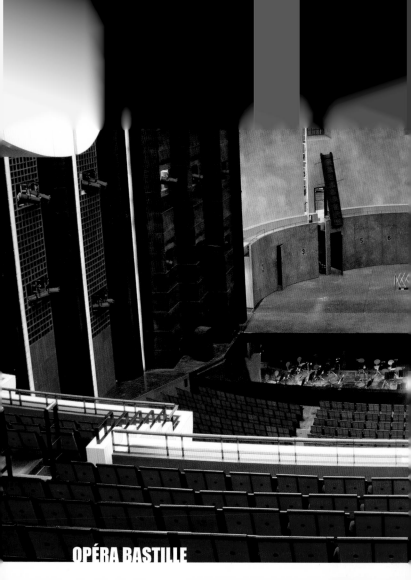

OPÉRA BASTILLE

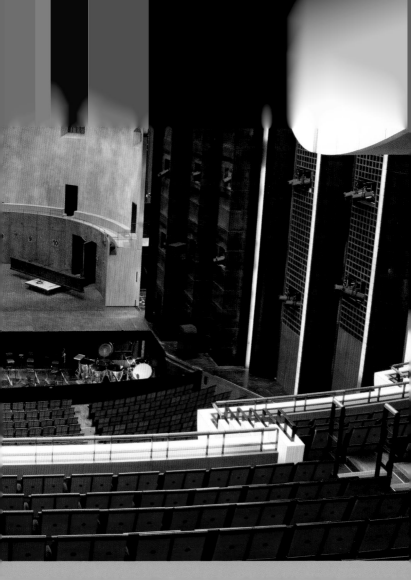

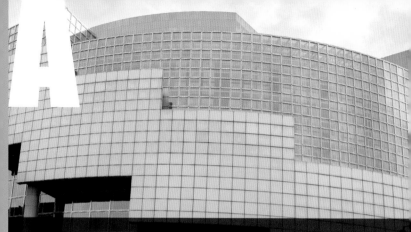

Another Grand Projet of the Mitterrand era was inaugurated in 1989 on the 200th anniversary of the storming of the Bastille: the opera house on the Place de la Bastille, designed by Carlos Ott and equipped with four stages. This monumental building is equally impressive inside and out by its shape and functionality. The auditorium, clad in granite and pear wood, radiates sophisticated elegance and offers seating for 2,700. Its acoustics and stage technology are among the best and most modern in Europe.

Rechtzeitig zum 200. Jahrestag des Sturms auf die Bastille wurde 1989 ein weiteres Grand Projet der Ära Mitterrand vollendet: die von Carlos Ott entworfene Oper an der Place de la Bastille mit vier Bühnen. Das monumentale Bauwerk besticht innen wie außen durch seine Form und Funktionalität. Der Zuschauerraum aus Granit und Birnenholz verströmt kühle Eleganz und bietet 2 700 Besuchern Platz. Seine Akustik und Bühnentechnik gilt als eine der besten und modernsten ganz Europas.

À l'occasion du bicentenaire de la prise de la Bastille, l'Opéra, érigé par Carlos Ott et comprenant quatre scènes, a vu le jour en 1989 à l'ère des Grands Projets de Mitterrand. L'intérieur et l'extérieur de l'édifice séduisent par leur forme et fonctionnalité. La salle principale en granit et bois de bouleau reflète une élégance froide et peut accueillir 2 700 personnes. Son acoustique et son installation technique comptent parmi les plus modernes d'Europe.

Con ocasión del bicentenario de la toma de la Bastilla se completó en 1989 un nuevo proyecto de la era Mitterrand: la ópera de la plaza de la Bastilla, obra de Carlos Ott y dotada de cuatro escenarios. El monumental edificio destaca por sus formas y funcionalidad exterior e interior. La sala principal, en granito y madera de peral, destila elegancia fresca y es capaz de acoger a 2 700 personas. Su acústica y tecnología escénica pasan por ser de las mejores y más modernas de Europa.

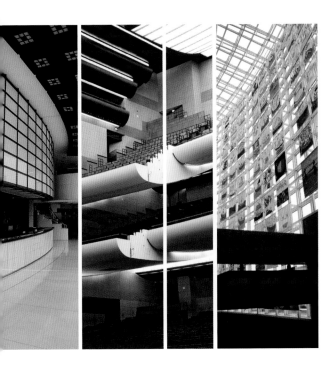

OPÉRA BASTILLE

120, rue de Lyon, Place de la Bastille // Bastille
Tel.: +33 (0)8 92 89 90 90
www.operadeparis.fr

Métro Bastille

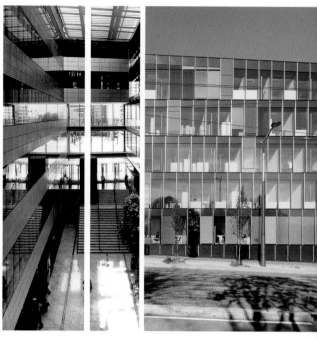

FRANCE TÉLÉVISIONS

7, esplanade Henri de France // Beaugrenelle
www.francetelevisions.fr

Métro Balard

The headquarters of the national French television broadcaster, France Télévisions, is located on the banks of the Seine in the 15th arrondissement. Jean-Paul Viguier's architecture, with its totally smooth façade in white roughened glass, plain glass, and white marble, offers openness and transparency. The building's arrangement in two columns is symbolic: the division represents the fact that the two channels, France 2 and France 3, coexist under the same roof.

Die Zentrale der staatlichen französischen Fernsehanstalt France Télévisions liegt direkt an der Seine im 15. Arrondissement. Die Architektur von Jean-Paul Viguier mit einer völlig glatten Fassade aus weißem, aufgerautem Glas, Normalglas und weißem Marmor demonstriert Offenheit und Transparenz. Symbolträchtig ist die Gliederung des Bauwerks in zwei Säulen. Die Zweiteilung steht für das Nebeneinander der beiden Programme France 2 und France 3 unter einem gemeinsamen Dach.

Le siège de la télévision publique française, France Télévisions, se situe en bord de Seine dans le XVe arrondissement. L'architecture de Jean-Paul Viguier symbolise la sincérité et la transparence avec sa façade mêlant verre blanc mat, verre classique et marbre blanc. La séparation obtenue à l'aide des deux piliers est emblématique et représente la cohabitation sous le même toit des deux chaînes France 2 et France 3.

La sede central de la cadena estatal France Télévisions se encuentra frente al Sena, en el distrito XV. La construcción de Jean-Paul Viguier, de fachada completamente lisa en vidrio lechoso, ventanas transparentes y mármol blanco, simboliza la transparencia y sinceridad de la institución. La estructuración en dos columnas del edificio tiene carácter simbólico: la división representa la coexistencia de los canales France 2 y France 3 bajo un mismo techo.

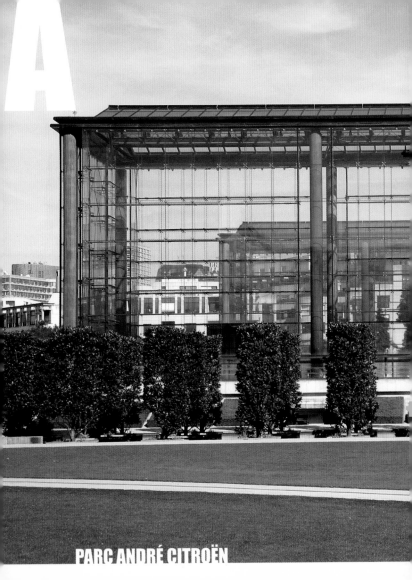

A

PARC ANDRÉ CITROËN

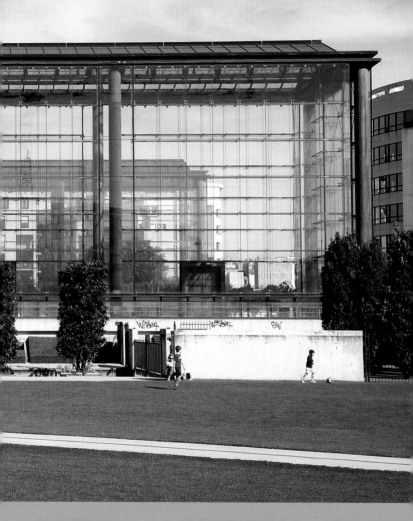

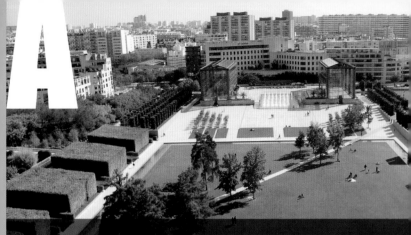

Nature, tamed: opened in 1992, this park is located on the site of a former Citroën automobile manufacturing plant and fits in perfectly with the modern buildings surrounding it. Landscape designers Gilles Clément and Alain Provost created a large central expanse of lawn, bounded on one end by two enormous greenhouses with exotic plants and dancing fountains, and adjoined by several themed gardens, including a metamorphosis garden, a black and white garden, and rock gardens.

Gezähmte Natur: Seit 1992 erstreckt sich auf dem einstigen Citroën-Werksgelände ein Park, der in einen spannenden Dialog mit den umliegenden modernen Häusern tritt. Die Landschaftsgärtner Gilles Clément und Alain Provost schufen eine große zentrale Wiese, an deren einer Stirnseite zwei riesige Gewächshäuser mit exotischen Pflanzen und Wasserspielen stehen und an die mehrere Themengärten angrenzen, etwa ein Metamorphosengarten, ein weißer und schwarzer Garten oder Steingärten.

Nature apprivoisée : ce parc situé sur les terrains de l'ancienne usine Citroën depuis 1992 est en parfaite harmonie avec les bâtiments modernes qui l'entourent. Les paysagistes Gilles Clément et Alain Provost ont conçu un parterre central au bout duquel se trouvent deux immenses serres accueillant des plantes exotiques. Les promeneurs peuvent flâner dans les nombreux jardins thématiques : le jardin blanc, le jardin noir, le jardin des métamorphoses ou les jardins de rocaille.

Naturaleza domada: desde 1992 se extiende un amplio parque sobre los antiguos terrenos de la fábrica Citroën en fascinante diálogo con las modernas casas circundantes. Los paisajistas Gilles Clément y Alain Provost concibieron un prado central en cuyo frente colocaron dos enormes invernaderos con plantas exóticas y fuentes ornamentales, con los que lindan varios jardines temáticos, como un jardín de las metamorfosis, otro en blanco y negro y un jardín pétreo.

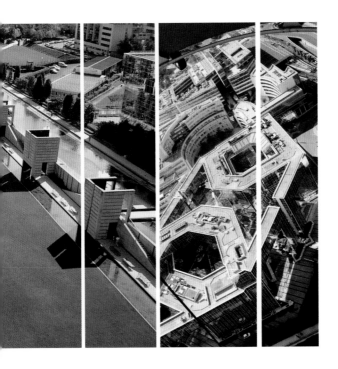

PARC ANDRÉ CITROËN

Quai André Citroën // Beaugrenelle

Métro Balard

CENTRE DE BIOTECHNOLOGIES BIOPARK

4–12, rue de la Croix de Jarry // Bercy
www.valode-et-pistre.com

Métro Bibliothèque François Mitterrand

This office complex from the '80s was transformed by Valode & Pistre in 2006 and integrated into the new university district. The building's structure remained unchanged, but its gables were covered with metal grids that extend like waves over the terraced façade down to the courtyard. They serve as climbing structures for plants which protect the offices from the sun. The central square transformed into a green oasis illustrates how the building's usage has changed.

Valode & Pistre gelang 2006 mit dem Umbau dieses Bürokomplexes aus den 80er Jahren eine Metamorphose und Integration in das neue Universitätsviertel. Seine Struktur blieb unverändert, die Giebel wurden jedoch mit Metallgittern überfangen, die wellenförmig über die terrassierte Fassade zum Hof herabgezogen sind. Sie dienen als Rankgerüste für Pflanzen, die die Büros vor Sonne schützen. Der in eine grüne Oase verwandelte Platz in der Mitte lässt die veränderte Nutzung erkennen.

En 2006, Valode & Pistre ont complètement métamorphosé ce complexe de bureaux des années 80 qu'ils ont intégré dans le nouveau quartier universitaire. Sa structure de base fut maintenue, les pignons furent cependant habillés de treillis métalliques qui s'étendent sur les façades étagées en terrasse jusqu'à la cour intérieure et servent de support végétal pour protéger les bureaux du soleil. La place centrale est devenue un îlot de végétation qui affiche fièrement sa métamorphose.

Valode & Pistre consiguieron en 2006 una auténtica metamorfosis en un antiguo complejo de oficinas de los años 80 para integrarlo en el nuevo bario universitario. La estructura se mantuvo intacta: la azotea, sin embargo, se cerró con un entramado metálico que desciende ondulada hasta el patio interior y sirve de soporte a las plantas que protegen el edificio de la luz directa del sol. La plaza interior pasó a ser un verde oasis que resalta los cambios efectuados.

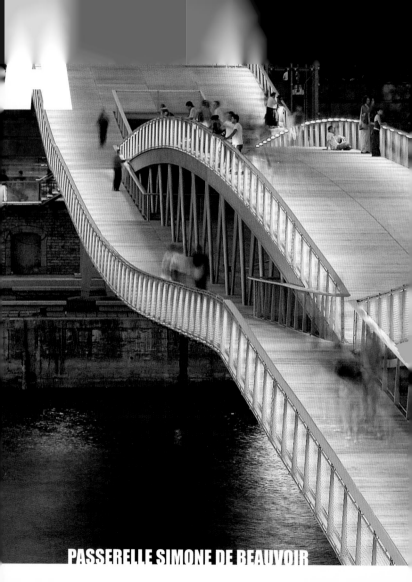

PASSERELLE SIMONE DE BEAUVOIR

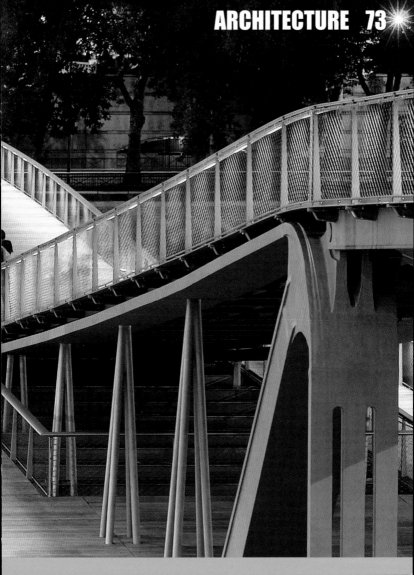

A

The Simone de Beauvoir footbridge, 997 ft. long, has linked the park of Bercy to the Bibliothèque nationale de France since 2006. The architect, Dietmar Feichtinger, succeeded in creating this light, elegant work of art by combining a suspension and an arched bridge, mutually stabilizing each other and thus avoiding the need for supports in the Seine itself. Pedestrians are offered differing perspectives depending on the section they are on.

Die Fußgängerbrücke Simone de Beauvoir verbindet seit 2006 mit einer Gesamtlänge von 304 m den Park von Bercy mit der Bibliothèque nationale de France. Dem Architekten Dietmar Feichtinger ist ein Kunstwerk voller Leichtigkeit und Eleganz gelungen, indem er eine Hängemit einer Bogenbrücke verband, die sich gegenseitig stabilisieren, sodass über der Seine auf Stützen verzichtet werden kann. Dem Fußgänger bieten sich verschiedene Perspektiven, ja nachdem, auf welchem Abschnitt er sich befindet.

La passerelle Simone de Beauvoir, d'une longueur totale de 304 m, relie le Parc de Bercy à la Bibliothèque nationale de France depuis 2006. Cette œuvre d'art de l'architecte Dietmar Feichtinger, pleine de légèreté et d'élégance, est le résultat de la combinaison d'un pont suspendu et d'un pont en arc stabilisant l'un l'autre et ne nécessitant aucun appui au dessus de la Seine. Les piétons peuvent apprécier de nombreuses perspectives différentes selon l'endroit où ils se trouvent sur la passerelle.

Los 304 m de longitud total del puente para peatones Simone de Beauvoir unen desde 2006 el parque de Bercy con la Bibliothèque nationale de France. Dietmar Feichtinger ha sabido crear un monumento liviano y elegante en el que se unen un puente colgante y un puente de arco que se estabilizan mutuamente, lo que permite renunciar a todo apoyo sobre el agua del Sena. Desde la pasarela se abren diversas perspectivas en función del tramo por el que transiten.

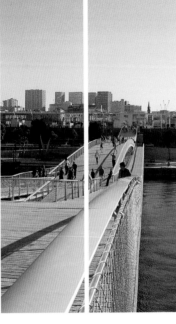

PASSERELLE
SIMONE DE BEAUVOIR

Quartier de Bercy // Bercy

Métro Bibliothèque François Mitterrand

A

Cour Saint-Émilion, lined by old warehouses with shops and bistros, leads through the largest movie theater multiplex in Paris to the Seine. Valode & Pistre combined the old and the new in subtle ways. The façades of the 18 theaters, built as concrete boxes, are clad with metal blinds while steel grids symbolize screens. Vertical corridors leading to the theaters ensure that moviegoers don't run into each other when arriving or exiting. At night, the structure is lit in blue.

Der Cour Saint-Émilion, gesäumt von alten Lagern mit Shops und Bistros, führt durch das größte Pariser Multiplexkino bis zur Seine. Valode & Pistre verbanden dabei Alt und Neu auf subtile Weise. Die als Betonboxen gestalteten 18 Säle sind an der Fassade mit Metalljalousien verschalt, während Stahlnetze Leinwände symbolisieren. Vertikale Zugänge führen zu den Sälen, ohne dass die Besucher sich beim Betreten oder Verlassen stören. Nachts illuminiert blaues Licht den Bau.

Bordée de vieux chais, de magasins et de bistros, la Cour Saint-Émilion mène au plus grand multiplexe de Paris et s'étend jusqu'à la Seine. Valode & Pistre ont allié le neuf et l'ancien avec subtilité. Les 18 salles dont la façade est blindée de persiennes métalliques et de treillis en acier symbolisant des écrans sont conçues comme des boîtes en béton. Les accès verticaux menant aux salles permettent un flux de visiteurs fluide. La nuit, les lumières bleues illuminent l'édifice.

Flanqueada por tiendas y restaurantes, la Cour Saint-Émilion atraviesa el mayor cine multisalas de París hasta llegar al Sena. Valode & Pistre han sabido combinar con sutileza lo nuevo con lo antiguo: las 18 salas, concebidas como cubos de hormigón, se asoman a la fachada tras persianas metálicas, y diversas redes de acero simbolizan las pantallas. Los accesos verticales conducen a las salas sin aglomeraciones a la entrada o la salida. De noche, una luz azul baña el edificio.

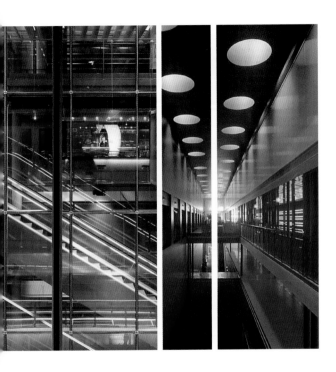

UGC CINÉ CITÉ BERCY

2, cour Saint-Émilion // Bercy
Tel.: +33 (0)8 92 70 00 00
www.ugc.fr

Métro Cour Saint-Émilion or Bercy

A

Visitors to Passage du Grand Cerf can stroll past workshops, jewelers, boutiques, and Indian and African designs, in an atmosphere of classicism. The 384 ft. long passage was erected in 1825 with a filigree cast-iron structure, and, at 39 ft. high, is the tallest passage in Paris. The name of the architect is unknown. After years of closure due to disrepair, it reopened in the '90s and has retained its luster ever since.

In der Passage du Grand Cerf flaniert der Besucher in einer Atmosphäre des Klassizismus an Ateliers, Juweliergeschäften, Boutiquen sowie indischem und afrikanischem Design vorbei. Das 1825 errichtete, 117 m lange Bauwerk mit der filigranen Gusseisenstruktur ist mit einer Deckenhöhe von 12 m die höchste Passage in Paris. Der Name des Architekten ist nicht bekannt. Nachdem die Passage lange Jahre wegen Baufälligkeit geschlossen war, erstrahlt sie seit den 90er Jahren in neuem Glanz.

Les visiteurs peuvent flâner dans le passage du Grand Cerf, dans une ambiance mêlant le classicisme des ateliers, des joailleries, des boutiques et le design indien et africain. Construit en 1825, ce passage à la structure en fonte de 117 m de long est, avec une hauteur de plafond de 12 m, le plus haut passage de Paris. Le nom de l'architecte n'est pas connu. Fermé durant des années car délabré, le passage a retrouvé ses lettres de noblesse dans les années 90.

En el Passage du Grand Cerf, el visitante deambula por un entorno clasicista entre talleres, joyerías, tiendas diversas y diseño indio y africano. Con sus 117 m de exquisita estructura en hierro colado, la galería, construida en 1825, puede alardear de techos de 12 m de alto. Se desconoce el nombre del arquitecto. Durante años, el estado ruinoso del Passage obligó a cerrarlo al público hasta que en los años 90 volvió a abrir sus puertas en todo su esplendor.

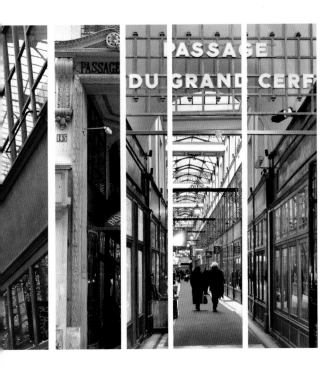

PASSAGE DU GRAND CERF

145, rue Saint-Denis // Étienne Marcel
www.passagedugrandcerf.com

Daily 8 am to 8 pm
Métro Étienne Marcel

LE CUBE

20, cours Saint-Vincent // Issy-les-Moulineaux
Tel.: +33 (0)1 58 88 30 00
www.lecube.com

Tue–Sat noon to 7 pm, Tue and Sat noon to 9 pm
Métro Porte de Versailles

Le Cube – Centre de création numérique is a unique center for digital technology and design established in Issy-les-Moulineaux in 2001. It is dedicated to the creative aspects of the digital world and serves as an information and education center. What do new aesthetic forms in the digital world look like? How do they influence architecture and design? The ART3000 society organizes exhibitions and events around art, architecture, and design.

Seit 2001 befindet sich in Issy-les-Moulineaux mit dem Le Cube – Centre de création numérique ein einzigartiges Zentrum für digitale Technologien und Design. Den kreativen Aspekten der digitalen Welt gewidmet, fungiert es als Informations- und Bildungszentrum. Wie sehen die neuen ästhetischen Formen in der digitalen Welt aus? Wie beeinflussen sie Architektur und Design? Die Gesellschaft ART3000 organisiert Ausstellungen und Events rund um Kunst, Architektur und Design.

Depuis 2001, Issy-les-Moulineaux abrite Le Cube – Centre de création numérique axé sur les technologies et le design numériques. Dédié à l'aspect créatif du monde numérique, ce bâtiment sert aussi de centre de formation et d'information. À quoi ressemblent les nouvelles formes esthétiques dans le monde numérique ? Comment influencent-elles architecture et design ? La société ART3000 y organise des expositions et manifestations autour de l'art, l'architecture et le design.

Desde 2001, Issy-les-Moulineaux cuenta con Le Cube – Centre de création numérique, un centro único en su género consagrado a las tecnologías y el diseño digitales y que ha devenido punto de formación e información sobre los aspectos creativos del mundo digital. ¿Cuáles son los nuevos modelos estéticos en el plano digital? ¿De qué modo afectan a la arquitectura y el diseño? La sociedad ART3000 organiza exposiciones y eventos relacionados con el arte, la arquitectura y el diseño.

At the heart of Europe's largest business district, La Défense, the architect Jean-Paul Viguier also created, in 2001, one of the largest office blocks in Europe, with a surface of 3,770,000 sq. ft. Every day around 10,000 people flock in and out of Cœur Défense. The centerpiece of the six-building complex are the 590 ft. high, 79 ft. wide twin towers. The hallmark of this construction is this elegant expression of form, not least the result of the rounded forms of each building.

Im Herzen von Europas größter Bürostadt La Défense hat der Architekt Jean-Paul Viguier 2001 mit 350 000 m² auch eines der größten Bürogebäude Europas geschaffen. Jeden Tag gehen im Cœur Défense durchschnittlich 10 000 Menschen ein und aus. Im Zentrum des Bauensembles aus sechs Gebäuden stehen die beiden 180 m hohen und 24 m breiten Zwillingstürme. Markenzeichen des Bauwerks ist die elegante Formensprache, die nicht zuletzt durch die abgerundeten Formen aller Baukörper entsteht.

Au cœur de La Défense, le plus grand centre d'affaires d'Europe, l'architecte Jean-Paul Viguier a conçu en 2001 l'un des plus grands pôles d'affaires en Europe d'une surface de 350 000 m². Chaque jour, en moyenne 10 000 personnes s'y croisent. Au milieu de l'ensemble architectural composé de six bâtiments s'élèvent les tours jumelles de 180 m de haut et 24 m de large. L'ensemble se caractérise par de sublimes formes, dont des formes arrondies d'une élégance indéniable.

En el corazón de La Défense, el mayor distrito de negocios de Europa, el arquitecto Jean-Paul Viguier erigió en 2001 uno de los mayores edificios de oficinas del continente (350 000 m²). Cada día entra y sale de Cœur Défense una media de 10 000 personas. En el centro del complejo de seis edificios se alzan dos torres gemelas de 180 m de alto y 24 m de ancho. El conjunto se caracteriza por una elegancia formal debida en buena parte a las formas redondeadas de sus elementos.

CŒUR DÉFENSE

110, esplanade du Général de Gaulle // La Défense

Métro La Défense

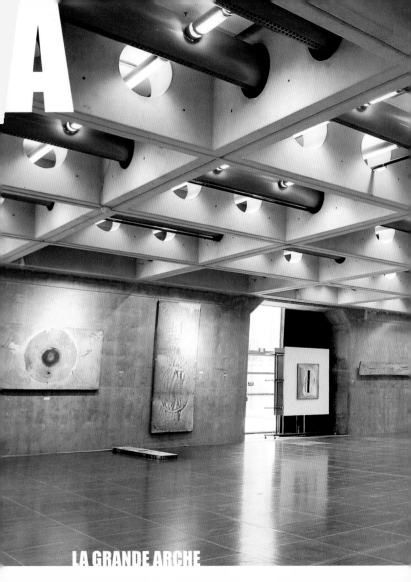

A

LA GRANDE ARCHE

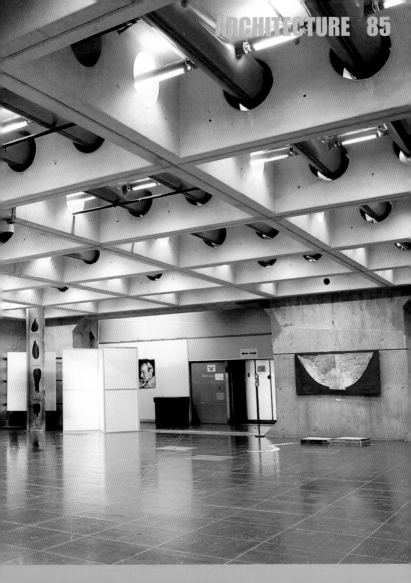

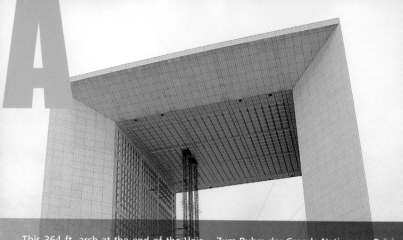

This 364 ft. arch at the end of the Voie Triomphale was initiated by President Mitterrand to celebrate the bicentennial of the French Revolution. The severe geometry of the cube, designed by Johan Otto von Spreckelsen and clad with glass and marble, is softened by the sail-shaped roof over the esplanade. The side walls house offices, and the upper floors offer impressive views of Paris and La Défense, symbolizing the architect's intentions to create a vision of the future.

Zum Ruhm der Grande Nation von Präsident Mitterrand initiiert, steht der 111 m hohe Bogen am Ende des Voie Triomphale. Die strenge Form des von Johan Otto von Spreckelsen entworfenen, mit Glas und Marmor verkleideten Kubus wird durch ein segelartiges Dach im Durchgang aufgelockert. In den Seitenwänden liegen Büros und von den oberen Etagen aus bietet sich ein imposanter Ausblick auf Paris und La Défense – gemäß des vom Architekten intendierten Blicks in die Zukunft.

Érigée à la gloire de la Grande Nation du Président Mitterrand, cette arche d'une hauteur de 111 m se situe à l'extrémité de la Voie Triomphale. La forme sévère de ce cube de verre et de marbre, conçu par Johan Otto von Spreckelsen, est adoucie par son toit voûté qui surplombe l'allée centrale. Les parois latérales abritent des bureaux et les étages supérieurs offrent une vue panoramique sur Paris et la Défense. Ses architectes l'ont définie comme « une fenêtre sur le monde ».

En el extremo de la Voie Triomphale se alza un arco de 111 m, promovido por el presidente Mitterrand a mayor gloria de la Grande Nation. Las severas formas del cubo de vidrio y mármol, diseñado por Johan Otto von Spreckelsen, se ven suavizadas por la carpa que cubre la apertura central. Diversas oficinas ocupan los laterales, y desde la azotea se abre una imponente vista de Paris y La Défense, definida en los planes del arquitecto como una mirada al futuro.

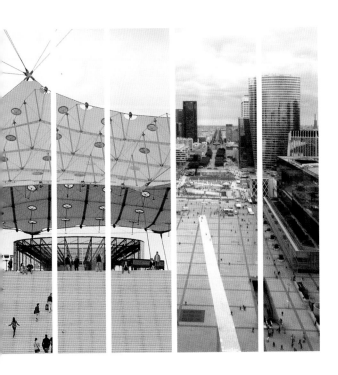

LA GRANDE ARCHE

La Défense
www.grandarche.com

Métro La Défense

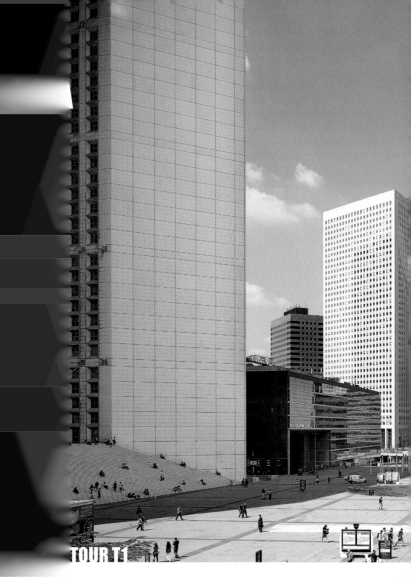

TOUR T1

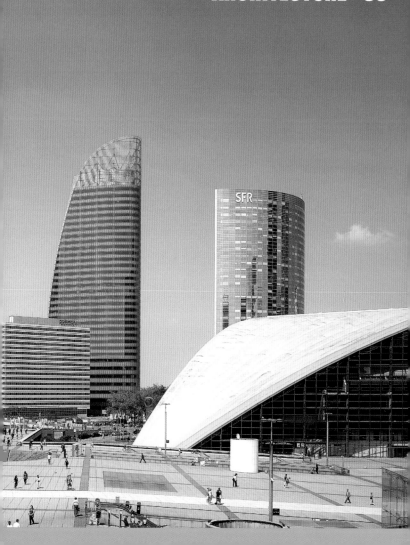

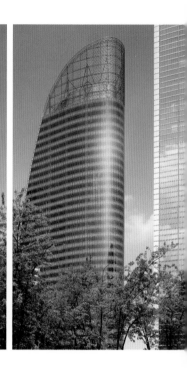

TOUR T1

1, place Samuel de Champlain // La Défense
www.tour-t1.com

Métro La Défense

The 607 ft. office tower by architects Denis Valode and Jean Pistre, completed in 2008, is currently the third tallest of La Défense, which is well on its way to becoming Manhattan on the Seine. Designed as a folded glass sheet with a curved north side, the building resembles the prow of a gigantic ship or a billowing sail, depending on the perspective, and fits in harmoniously with the existing environment. Its high energy efficiency makes it a next-generation skyscraper.

Der 185 m hohe Büroturm der Architekten Denis Valode und Jean Pistre ist derzeit der dritthöchste von La Défense, das auf bestem Wege ist, zum Manhattan der Seine zu werden. Konzipiert als eine gefaltete Glasplatte mit einer geschwungenen Nordseite, wirkt der 2008 vollendete Bau je nach Ansicht wie der Bug eines riesigen Schiffs oder ein geblähtes Segel und fügt sich in die bestehende Bebauung ein. Seine hohe Energieeffizienz macht ihn zu einem Hochhaus der neuen Generation.

Cette tour de 185 m, abritant des bureaux et conçue par Denis Valode et Jean Pistre, est la troisième tour la plus haute de La Défense, le Manhattan du bord de Seine. Selon l'angle d'observation, cet édifice de verre plissé, inauguré en 2008, ressemble avec sa façade nord voûtée à la proue d'un bateau ou à une voile bombée par le vent. L'ensemble s'accorde avec l'aménagement des alentours. Sa grande efficience énergétique la place au rang des gratte-ciels de nouvelle génération.

El bloque de oficinas de los arquitectos Denis Valode y Jean Pistre (185 m) es el tercer edificio más alto de La Défense, zona en la que muchos ven ya el Manhattan del Sena. Concebido como una plancha de vidrio ondulada en su fachada norte, el edificio, completado en 2008, aparece a veces como la proa de un inmenso navío o una vela henchida por el viento, armoniosamente integrada en el entorno. Su alta eficiencia energética hace de él un rascacielos de nueva generación.

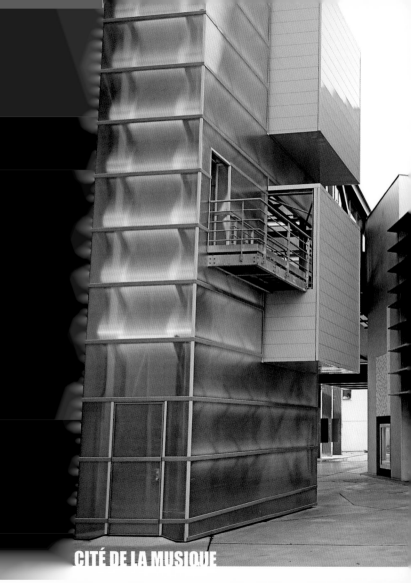

CITÉ DE LA MUSIQUE

CITÉ DE LA MUSIQUE

221, avenue Jean Jaurès // La Villette
Tel.: +33 (0)1 44 84 44 84
www.cite-musique.fr

Tue–Sat noon to 6 pm, Sun 10 am to 6 pm
Métro Porte de Pantin

Opened in 1995 after ten years of construction, Cité de la Musique, the brainchild of architect Christian de Portzamparc, is a postmodern city whose shapes reflect the richness of music. Clustered around a concert hall are a conservatory, studios, a media library, as well as a museum where sound samples and 800 instruments from the Renaissance until today, including pieces from legendary instrument makers and musicians, make music come alive.

Die nach zehn Jahren Bauzeit 1995 eröffnete Cité de la Musique des Architekten Christian de Portzamparc ist eine postmoderne Stadt für sich, deren Formen den Reichtum der Musik spiegeln. Um einen Konzertsaal sind ein Konservatorium, Studios, eine Mediathek und ein Museum gruppiert. Letzteres macht mit 800 Instrumenten von der Renaissance bis heute, darunter Einzelstücke legendärer Instrumentenbauer oder Musiker, und Tonbeispielen die Welt der Musik vielfältig erfahrbar.

La Cité de la Musique de l'architecte Christian de Portzamparc, inaugurée en 1995, est une ville postmoderne à part entière, dont les formes diverses reflètent la richesse de la musique. La salle de concert centrale est entourée d'un conservatoire, de studios, d'une médiathèque et d'un musée. Les 800 instruments de la Renaissance à nos jours, dont des pièces d'illustres luthiers et de grands musiciens, et les archives sonores vous feront vivre une expérience auditive.

La Cité de la Musique del arquitecto Christian de Portzamparc, inaugurada en 1995, es en sí misma una ciudad posmoderna cuyas formas reflejan la multiplicidad de la música. En torno a la sala central de conciertos se encuentran un conservatorio, varios estudios, una mediateca y un museo, en el que 800 instrumentos clásicos y modernos (algunas piezas únicas de músicos y luthiers legendarios) y diversas muestras acústicas acercan el visitante al mundo de la música.

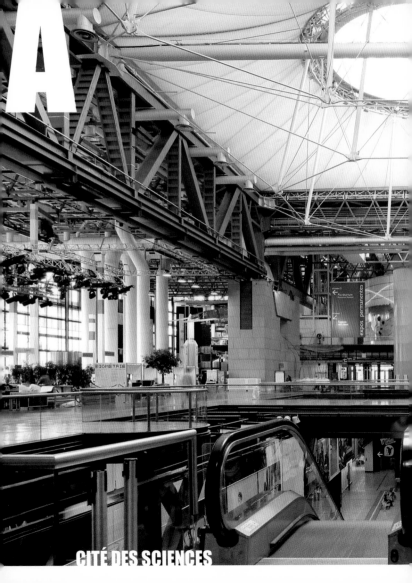

A

CITÉ DES SCIENCES

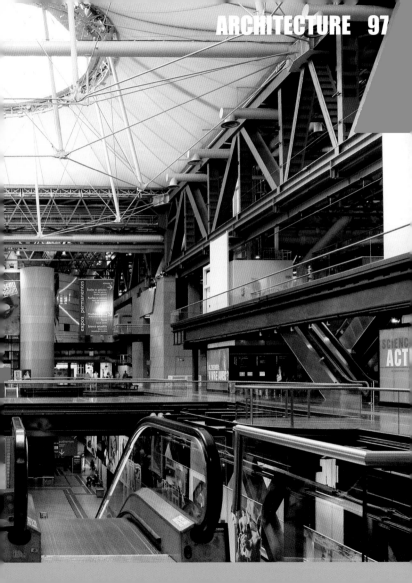

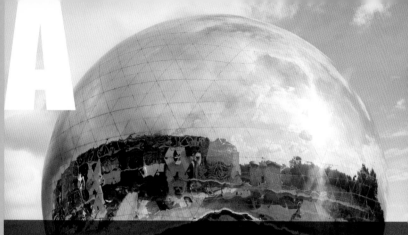

A

Designed by architect Adrien Fainsilber and resembling a futuristic factory of steel and glass, this science and technology museum opened in 1986. Its mission is to spread scientific and technical knowledge; through interactive experiments, it introduces visitors to many different natural phenomena. Special exhibitions focusing on the environment and industrial design complete the program. A giant silver sphere, called La Géode, is home to a spectacular 3-D movie theater.

Das 1986 eröffnete Technik- und Industriemuseum des Architekten Adrien Fainsilber wirkt selbst etwas wie eine futuristische Fabrik aus Stahl und Glas. Allerdings eine Fabrik des Wissens, die ihren Besuchern Phänomene aus Naturwissenschaft und Technik mittels interaktiver Experimente spielerisch vermittelt. Wechselausstellungen zu Themen aus Umwelt und Industriedesign runden die Sammlung ab. Eine riesige silberne Kugel – La Géode – verbirgt ein spektakuläres 3-D-Kino.

Le musée des sciences et techniques de l'architecte Adrien Fainsilber, inauguré en 1986, ressemble à une usine futuriste constituée d'acier et de verre. Usine du savoir, elle fait découvrir de manière ludique à ses visiteurs des phénomènes de science naturelle et technique à travers des expériences interactives. Des expositions temporaires traitant de l'écologie et du design industriel complètent le programme. L'immense boule d'argent appelée la Géode abrite un cinéma 3D.

El museo de la ciencia y la industria ideado en 1986 por el arquitecto Adrien Fainsilber evoca una futurista fábrica de acero y cristal; una fábrica del conocimiento, que mediante experimentos interactivos acerca al visitante a los más diversos fenómenos de la tecnología y las ciencias naturales. Completan la colección exposiciones centradas en cuestiones medioambientales y de diseño industrial. Una inmensa esfera plateada, la Géode, alberga un espectacular cine en 3-D.

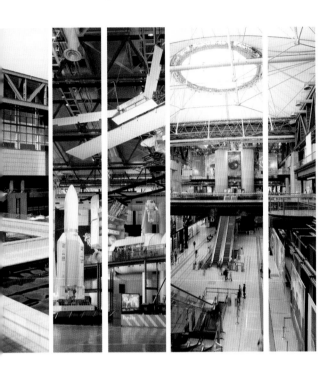

CITÉ DES SCIENCES

30, avenue Corentin Cariou // La Villette
Tel.: +33 (0)1 40 03 75 75
www.cite-sciences.fr

Tue–Sat 10 am to 6 pm, Sun 10 am to 7 pm
Dec 26th and 31st: 10 am to 4.30 pm
Métro Porte de la Villette

AXA PRIVATE EQUITY

20, place Vendôme // Louvre

Métro Pyramides

Fashionable Place Vendôme is home not only to the most exclusive jewelers in the world, but also to the headquarters of AXA Private Equity. In 2006, the interior of this 18th century building was sensitively renovated by AS. Architecture-Studio. Elegant materials, combined in purist fashion, create a light and lucid atmosphere, accented by dark woods. Simple staircases of glass and metal connect the different floors. Natural light is used where possible to illuminate the rooms.

Am Place Vendôme, wo die teuersten Juweliere ihren Sitz haben, erstrahlt der Hauptsitz der AXA Private Equity seit 2006 in neuem Glanz. Das Innere des Gebäudes aus dem 18. Jahrhundert haben AS. Architecture-Studio behutsam modernisiert. Edle Materialien, in puristischer Manier kombiniert, schaffen eine klare Atmosphäre, akzentuiert von dunklen Hölzern. Schlichte Treppen aus Glas und Metall verbinden die Etagen, und natürliches Licht erhellt die Räume wo immer möglich.

Sur la noble place Vendôme, où les joailliers les plus chers ont élu domicile, le siège principal d'AXA Private Equity brille d'un nouvel éclat depuis 2006. L'intérieur datant du XVIIIᵉ siècle fut modernisé par AS. Architecture-Studio. La combinaison puriste de matériaux nobles crée une atmosphère légère et lumineuse, accentuée par des boiseries sombres. Des escaliers transparents en verre et métal mènent aux étages supérieurs et permettent d'illuminer naturellement les pièces.

En la noble plaza Vendôme, rodeada por las más caras joyerías, la sede central de AXA Private Equity brilla con luz propia desde 2006. El interior del edificio, que data del siglo XVIII, ha sido primorosamente modernizado por AS. Architecture-Studio. La purista combinación de materiales nobles crea un ambiente luminoso y claro acentuado por el tono oscuro de las maderas. Sencillas escaleras de vidrio y metal comunican las plantas, y la luz natural ilumina en lo posible todas las salas.

A

A monumental glass office complex was erected in 1997 on the same plot where there was once a Jacobin monastery during the French Revolution and then later a car park in the '50s. Ricardo Bofill, the architect, built over Place du Marché Saint-Honoré following the model of Victor Baltard's market halls. A covered street leads between the two largely glazed sections, in which a mix of businesses, boutiques, cafés, and offices are located.

Dort, wo sich zur Zeit der französischen Revolution ein Jakobinerkloster befand und in den 50er Jahren ein Parkhaus, steht seit 1997 ein monumentaler Büro- und Geschäftskomplex aus Glas. Der Architekt Ricardo Bofill hat den Place du Marché Saint-Honoré nach dem Vorbild der Markthallen des Architekten Victor Baltard bebaut. Zwischen den beiden großflächig verglasten Bauteilen führt eine überdachte Straße hindurch, an der eine Mischung aus Geschäften, Boutiquen, Cafés und Büros liegt.

À l'endroit où se dressa le couvent des Jacobins à l'époque de la révolution française puis un parking dans les années 50, on trouve depuis 1997, un complexe réalisé en verre regroupant magasins et bureaux. Pour concevoir la Place du Marché Saint-Honoré, l'architecte Ricardo Bofill s'est inspiré des marchés couverts de l'architecte Victor Baltard. Entre deux bâtiments habillés de verre, une rue couverte vous conduit vers des magasins, boutiques, cafés et bureaux.

En el espacio ocupado por un convento jacobino durante la Revolución Francesa y por un aparcamiento en los años 50 del siglo XX se alza desde 1997 un monumental edificio vidriado de oficinas y tiendas. En el diseño del edificio, Ricardo Bofill tomó como modelo los mercados del arquitecto Victor Baltard. Una vía cubierta transcurre entre los dos bloques principales del complejo, flanqueada por diversas tiendas, boutiques, oficinas y cafés.

PLACE DU
MARCHÉ SAINT-HONORÉ

Place du Marché Saint-Honoré // Louvre

Métro Pyramides

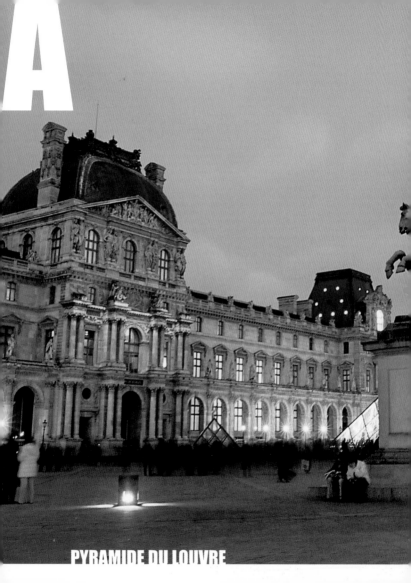

A

PYRAMIDE DU LOUVRE

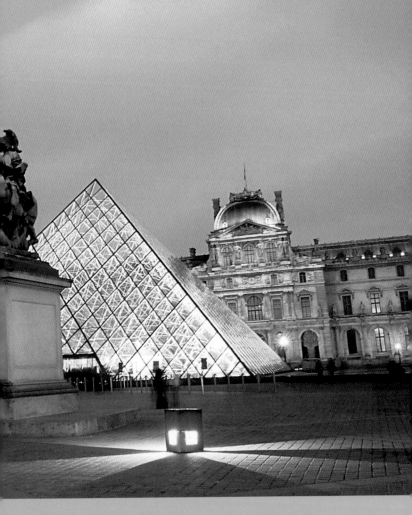

PYRAMIDE DU LOUVRE

Musée du Louvre // Louvre
www.louvre.fr

Wed–Mon 9 am to 6 pm, Wed and Fri 9 am to 10 pm
Closed on Jan 1st, May 1st, and Dec 25th
Every first Sun of the month and Jul 14th free access
Métro Palais Royal / Musée du Louvre

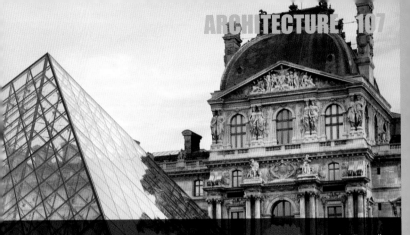

In 1989, president François Mitterrand initiated the Grand Louvre project in celebration of the 200th anniversary of the French Revolution. The Richelieu Wing, the former seat of the Finance Ministry, was added to the museum, and renowned architect Ieoh Ming Pei designed a pyramid in the Cour Napoléon as the new main entrance. It forms the start of the Voie Triomphale, and thanks to its airy structure, seems to float over the new underground lobby like a finely cut diamond.

Anlässlich der 200-Jahr-Feier der Französischen Revolution 1989 initiierte Staatspräsident François Mitterrand das Großprojekt Le Grand Louvre. Das Museum wurde um den Richelieu-Flügel, zuvor Sitz des Finanzministeriums, erweitert, und Stararchitekt Ieoh Ming Pei errichtete im Cour Napoléon eine Pyramide als neuen Haupteingang. Dank ihrer luziden Struktur schwebt sie gleich einem geschliffenen Diamanten über einem unterirdischen Entree und bildet den Beginn des Voie Triomphale.

À l'occasion du bicentenaire de la Révolution Française, François Mitterrand valida le projet du Grand Louvre. Le musée fut agrandi de l'aile Richelieu qui abritait autrefois le Ministère des Finances. Dans la cour Napoléon, l'architecte Ieoh Ming Pei érigea une pyramide qui constitue depuis la nouvelle entrée principale. Sa structure légère et translucide lui confère l'aspect d'un diamant taillé qui flotte au-dessus d'une entrée souterraine qui mène à la Voie Triomphale.

Con ocasión del bicentenario de la Revolución Francesa, el entonces presidente François Mitterrand puso en marcha el proyectode Le Grand Louvre. El museo se amplió con el ala Richelieu (antigua sede del Ministerio de Finanzas), y en la Cour Napoléon el arquitecto Ieoh Ming Pei erigió una pirámide, la nueva entrada al recinto. Gracias a su estructura liviana y luminosa se eleva como un diamante pulido sobreel vestíbulo subterráneo y marca el comienzo de la voie triomphale.

This church, designed by AS. Architecture-Studio and completed in 1998, is simple and unadorned. Twelve columns symbolizing the apostles and tribes of Israel support a cube enclosed by a grid structure. Stairs from the baptismal chapel on the ground floor lead to the main section of the church where the grid structure is repeated above the altar. Two glass windows by Martial Raysse (2001) let light into the indirectly illuminated space and create a meditative atmosphere.

Die 1998 vollendete Kirche von AS. Architecture-Studio besticht durch ihre schlichte Ästhetik. Zwölf Pfeiler, die die Apostel und Stämme Israels symbolisieren, tragen einen von einer Gitterstruktur umhüllten Kubus. Von der Taufkapelle im Erdgeschoss führt eine Treppe in den Kirchenraum, wo die Gitterstruktur über dem Altar wieder aufgegriffen wird. Zwei Glasfenster von Martial Raysse (2001) erhellen den ansonsten indirekt beleuchteten Raum und erzeugen eine meditative Stimmung.

Achevée en 1998 par AS. Architecture-Studio, l'église se distingue par la simplicité de son esthétique sacrée. Le cube central est entouré d'une résille métallique et supporté de douze colonnes symbolisant les apôtres et les peuples d'Israël. L'accès à la nef, dont l'autel est surmonté de la même résille métallique, s'effectue par un escalier situé dans le baptistère au rez-de-chaussée. Les deux vitraux dus à Martial Raysse (2001) illuminent la pièce et invitent à la méditation.

La iglesia diseñada por AS. Architecture-Studio (1998) se caracteriza por una estética sacra muy severa. Doce pilares simbolizan los apóstoles y las tribus de Israel y prestan soporte al cubo, envuelto en una estructura cuadriculada. Desde la capilla bautismal asciende una escalera a la nave central en la que se retoma la estructura cuadriculada sobre el altar. Dos vidrieras de Martial Raysse (2001) complementan la iluminación indirecta del espacio e invitan a la meditación.

NOTRE DAME
DE L'ARCHE D'ALLIANCE

81, rue d'Alleray // Montparnasse
Tel.: +33 (0)1 56 56 62 56
www.ndarche.org

Daily 8 am to 8 pm
Métro Volontaires

ÉCOLE DE COMMERCE ADVANCIA

3, rue Armand Moisant // Montparnasse

Métro Falguière

The expansion of the Advancia Business School completed by AS. Architecture-Studio in 2009 proves that it is possible to create an intriguing dialog between a building from 1908 and contemporary architecture. The original rectangular brick structure is juxtaposed by a curved glass building whose façade has vertical sun shades. Their changing colors give the building an added dynamic; depending on how far they are opened, the façade can vary between opaque and transparent.

Wie Architektur von 1908 mit zeitgenössischer Baukunst in einen spannenden Dialog gebracht werden kann, zeigt der Aus- und Umbau der Handelsschule Advancia von AS. Architecture-Studio von 2009. In Kontrast zu dem blockhaften Altbau aus Ziegelstein steht ein geschwungener Glasbau, an dessen Fassade vertikale Sonnenblenden angebracht sind. Ihre changierende Farbigkeit verleiht dem Bau zusätzliche Dynamik, und je nach Öffnungsgrad wirkt die Fassade opak oder transparent.

La restructuration et l'expansion de l'école de commerce Advancia, entreprise en 2009 par AS. Architecture-Studio, est un exemple où l'architecture de 1908 s'accorde parfaitement aux modèles contemporains. Contrastant avec la stabilité et la rugosité de la brique d'origine, l'extension du bâtiment est lisse et dynamique. Sa façade vitrée est protégée du soleil par des volets verticaux mobiles et change de couleur selon leur inclinaison. Elle parait opaque ou transparente.

La ampliación y remodelación de la escuela de comercio Advancia, acometida por AS. Architecture-Studio en 2009, es un ejemplo de cómo entroncar la arquitectura de 1908 con modelos contemporáneos. El antiguo bloque de ladrillo contrasta con las ondulaciones de la construcción vidriada, sobre cuya fachada se han instalado parasoles verticales que dan un dinamismo suplementario al edificio y, en función del grado de apertura, hacen que la fachada parezca transparente u opaca.

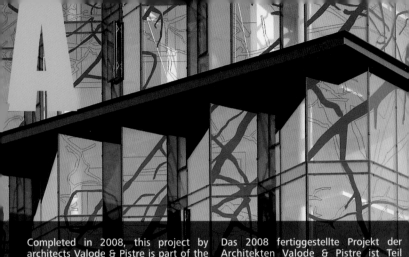

A

Completed in 2008, this project by architects Valode & Pistre is part of the redesign of Porte des Lilas and aims to create a synthesis between city and suburbs. The L-shaped building framing a garden is energy-efficient and its façades are in harmony with the environment, such as the 367 ft. northwestern façade with its irregular folds. Some of its glass surfaces are printed with the branches of a chestnut tree, designed by artist Elisabeth Ballet.

Das 2008 fertiggestellte Projekt der Architekten Valode & Pistre ist Teil der Neugestaltung der Port de Lilas und will eine Synthese zwischen Stadt und Vororten herstellen. Das L-förmige, einen Garten rahmende Haus ist energieeffizient und zeichnet sich durch seine auf die Umgebung abgestimmten Fassaden aus, etwa die 112 m lange, unregelmäßig gefaltete Nordwest-Fassade, deren Scheiben teilweise mit dem Geäst eines Kastanienbaums der Künstlerin Elisabeth Ballet bedruckt sind.

Partie intégrante d'un programme de réaménagement urbain de la Porte des Lilas, ce projet des architectes Valode & Pistre finalisé en 2008 a pour objectif de rétablir la continuité entre Paris et sa banlieue. Situé autour d'une esplanade verte, le Cinétic épouse une forme de L et déploie sur une longueur de 112 m sa façade nord-ouest plissée et vitrée dont les plaques de verre sont sérigraphiées d'un motif de marronnier de l'artiste Elisabeth Ballet.

El proyecto de Valode & Pistre, completado en 2008, forma parte de la remodelación del Port de Lilas y pretende trazar una síntesis entre la urbe y el área metropolitana. La eficiencia energética del edificio, rodeado por un jardín, es excelente. Llaman la atención las fachadas, adaptadas a su entorno: buen ejemplo de ello son los pliegues irregulares de la fachada noroeste de 112 m, decorados por la artista Elisabeth Ballet con tonos claros o el dibujo de las ramas de un castaño.

CINETIC

12–16, avenue de la Porte des Lilas // Porte des Lilas

Métro Porte des Lilas or Mairie des Lilas

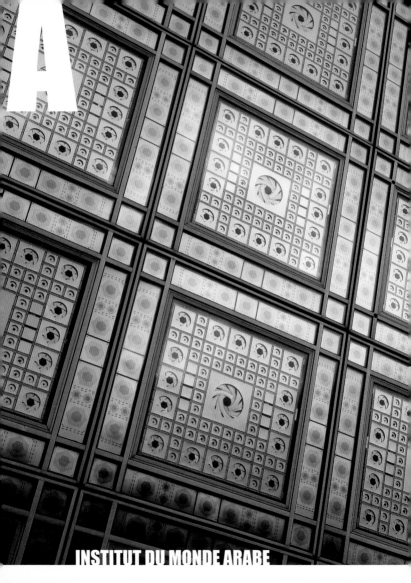

A

INSTITUT DU MONDE ARABE

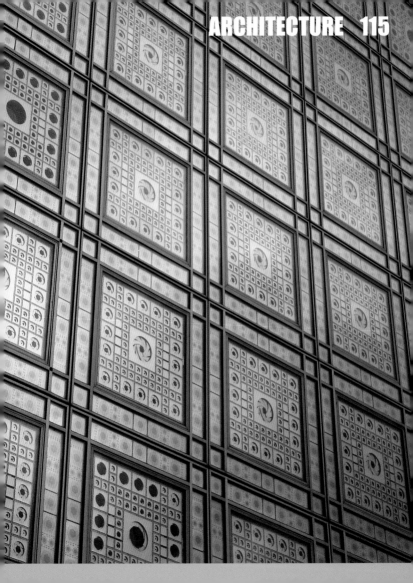

INSTITUT DU MONDE ARABE

1, rue des Fossés-Saint-Bernard // Quartier Latin
Tel.: +33 (0)1 40 51 38 38
www.imarabe.org

Tue–Sun 10 am to 6 pm
Métro Jussieu

معهد العالم العربي

Arab World Institute (AWI) was designed by Jean Nouvel in cooperation with AS. Architecture-Studio and opened in 1987. Its southern façade combines traditional Arab elements with high-tech features: 240 apertures inspired by mashrabiyas automatically control the amount of light entering the building. With its museum, library, and documentation center, AWI is a joint project between France and 22 Arab countries to promote understanding of and dialog with Arab civilizations.

Bei dem Kulturinstitut, das Jean Nouvel 1987 mit AS. Architecture-Studio entwarf, vereinte er an der Südfassade auf meisterhafte Weise traditionelle arabische und Hightech-Elemente: 240 an Maschrabiyyas angelehnte Irisblenden regulieren die Verschattung im Inneren automatisch. Das Institut mit Museum, Bibliothek und Dokumentationszentrum ist ein Gemeinschaftsprojekt zwischen Frankreich und 22 arabischen Ländern und dient dem Verständnis der arabischen Zivilisation und dem Dialog.

La façade sud de l'institut, conçu par Jean Nouvel et AS. Architecture-Studio en 1987, réunit architecture traditionnelle arabe et éléments haute technologie : 240 moucharabiehs munis de diaphragmes s'ouvrent et se referment pour régler la pénombre intérieure. Avec un musée, une bibliothèque et un centre de documentation, l'institut est né d'une collaboration entre la France et 22 pays arabes. Vecteur de la culture arabe, il favorise le dialogue entre l'Orient et l'Occident.

En el instituto cultural que diseñó junto con AS. Architecture-Studio en 1987, Jean Nouvel supo combinar a la perfección sobre la fachada sur elementos tradicionales árabes y la última tecnología: 240 diafragmas inspirados en las celosías árabes regulan automáticamente la cantidad de luz en el interior. El instituto, proyecto de cooperación entre Francia y 22 países árabes, cuenta con un museo, una biblioteca y un centro de documentación y promueve el diálogo intercultural.

In 1987, Jean Nouvel was brought to international fame by a striking Parisian building. The Institut du Monde Arabe was one of numerous Grands Projets initiated by President Mitterrand to add new architectural accent to the Seine during the '80s. He followed this with further international success: the Museum of Culture on Quai Branly in Paris, Galerie Lafayette in Berlin, and the Torre Agbar in Barcelona. In 2008, his achievements were crowned by one of the most prestigious architectural honors, the Pritzker Prize. Nouvel sees his functions as architect, planner and designer as being intertwined, feeling that societal and cultural values are what form a product irrespective of whether it is a construction, piece of furniture, or garden. His works therefore defy classification into a uniform language of design. His workshops now have over 150 staff from 25 countries. His company founded in 1995, Jean Nouvel Design, is a reflection of his enthusiasm for interiors, often working in tandem with his architectural firm.

Ein aufsehenerregendes Gebäude in Paris verhalf Jean Nouvel 1987 zum internationalen Durchbruch. Das Institut du Monde Arabe war eines der vielen Grands Projets, die Staatspräsident François Mitterrand initiierte und die in den 80er Jahren an der Seine neue architektonische Akzente setzten. Es folgten weltweit weitere Meisterwerke wie das Museum der Kulturen am Quai Branly in Paris, die Galerie Lafayette in Berlin und der Torre Agbar in Barcelona. Im Jahr 2008 erhielt er als Krönung seines Schaffens eine der renommiertesten Architektenauszeichnungen, den Pritzker Prize. Jean Nouvel sieht seine Aufgabe als Architekt, Städteplaner und Designer immer als eine Einheit. Für ihn formen die gesellschaftlichen und kulturellen Werte das Produkt, ganz gleich, ob es sich um ein Bauwerk, ein Möbel oder einen Garten handelt. Sein Schaffen entzieht sich daher auch einer einheitlichen Formensprache. Die Ateliers Jean Nouvel beschäftigen heute über 150 Mitarbeiter aus 25 Ländern. Sein 1995 neugegründetes Unternehmen Jean Nouvel Design spiegelt seine Begeisterung für Innenarchitektur und Design wider und arbeitet häufig mit seinem Architekturbüro zusammen.

En 1987, l'inauguration d'un bâtiment sensationnel à Paris permit à Jean Nouvel de lancer sa carrière internationale. La construction de l'Institut du Monde Arabe, bâtiment inscrit dans la politique de Grands Projets du Président François Mitterrand, donna, dans les années 80, un nouveau décor architectural à la Seine. D'autres chefs d'œuvres suivirent, comme le Musée des cultures du Quai Branly à Paris, la Galerie Lafayette à Berlin et la Torre Agbar à Barcelone. En 2008, ses travaux furent couronnés du Pritzker Prize, l'un des prix d'architecture les plus renommés. Jean Nouvel a toujours considéré dans son travail que l'architecture, l'urbanisme et le design ne faisaient qu'un. Pour lui, les valeurs sociales et culturelles forment la base de tout produit, qu'il s'agisse d'un bâtiment, meuble ou jardin. Ses travaux s'éloignent ainsi du concept d'un langage uniforme des formes. Les ateliers Jean Nouvel emploient aujourd'hui plus de 150 personnes de 25 pays différents. L'entreprise Jean Nouvel Design, qu'il fonda en 1995, reflète sa passion pour l'architecture d'intérieur et le design et travaille souvent en coopération avec son bureau d'architecture.

Un edificio particularmente llamativo erigido en París en 1987 sirvió a Jean Nouvel para darse a conocer internacionalmente. El Institut du Monde Arabe fue uno de los muchos grandes proyectos puestos en marcha por el presidente François Mitterrand que durante la década de 1980 cambiaron el panorama arquitectónico a orillas del Sena. A aquel proyecto siguieron otras obras maestras como el Museo de las Culturas en el Quai Branly de París, la Galerie Lafayette en Berlín y la Torre Agbar en Barcelona. En 2008 alcanzó la cumbre profesional al ser galardonado con el Pritzker Prize, el premio de mayor prestigio en la arquitectura. Jean Nouvel considera que sus diversas facetas de arquitecto, urbanista y diseñador forman un todo indivisible. Para él, los valores sociales y culturales dan forma al producto, tanto si se trata de un edificio como de un mueble o un jardín. Como consecuencia de ello, sus creaciones escapan a un lenguaje formal uniforme. Los despachos de Jean Nouvel cuentan en la actualidad con 150 empleados, distribuidos en 25 países. La empresa Jean Nouvel Design, fundada en 1995, es reflejo de su pasión por el interiorismo y el diseño, y son habituales las colaboraciones con su despacho de arquitectos.

DESIGN

D

The link between pleasure, aesthetics, and entertainment takes up new meaning in Paris. Here, creative cuisine meets interior design as top chefs and designers share a single passion: the wish to invent and to give their areas specific style. Whether in Andy Wahloo, Oth Sombath, or Makassar Lounge & Restaurant, international influences from across the globe are expertly blended with Parisian chic and integrated into these gourmet temples. Many hotels, restaurants, bars, showrooms, and department stores bear hallmarks of renowned designers, and as they vie for the most exceptional setting, new highlights are constantly being created, such as the Hermès flagship store in a renovated swimming pool in Saint-Germain-des-Prés or the karaoke restaurant in the refitted Renard. In the hotel scene, designers combine technical zeitgeist into their interior design work. Probably the most famous creative mind to come out of Paris, Philippe Starck, has left his mark on this city like practically nobody else has managed.

Die Verbindung zwischen Genuss, Ästhetik und Unterhaltung erhält in Paris eine neue Bedeutung. Hier trifft kreative Kochkunst auf spektakuläres Interior Design, denn Meisterköche und Kreative teilen eine Leidenschaft: Sie wollen schöpferisch sein und ihren Räumen einen besonderen Stil verleihen. Ob im Andy Wahloo, Oth Sombath oder Makassar Lounge & Restaurant, internationale Einflüsse aus aller Welt werden geschickt mit Pariser Schick verbunden und in das Interieur der Gourmettempel integriert. Zahlreiche Hotels, Restaurants, Bars, Showrooms und Kaufhäuser tragen die Handschrift renommierter Designer, und das Wetteifern um die außergewöhnlichste Ausstattung bringt immer wieder neue Highlights hervor, wie das zum Hermès Flagship-Store umgebaute Schwimmbad in Saint-Germain-des-Prés oder das zum Szene-Karaoke-Restaurant umgebaute Renard. In der Hotellerie binden die Designer den technischen Zeitgeist geschickt in das Raumdesign ein. Der wohl berühmteste Kreative von Paris, Philippe Starck, prägt die Metropole dabei wie kaum ein anderer.

Le mélange entre délice, esthétisme et divertissement prend une nouvelle tournure à Paris. On y savoure une gastronomie créative dans un décor design spectaculaire. Grands chefs et artistes partagent une passion commune, celle de combiner le plaisir visuel au plaisir gourmand. Que ce soit au Andy Wahloo, Oth Sombath ou Makassar Lounge & Restaurant, les influences internationales sont combinées au charme de l'élégance parisienne et intégrées au décor du temple gourmet. De nombreux hôtels, restaurants, bars, galeries et centres commerciaux portent la griffe de grands designers et la rivalité est de mise quand il s'agit de créer des décors extraordinaires comme cette ancienne piscine de Saint-Germain-des-Prés réaménagée en magasin phare Hermès ou du Renard transformé en restaurant karaoké au décor de music hall. Les progrès techniques ont aussi trouvé leur place dans les intérieurs design du monde de l'hôtellerie. On retrouve l'empreinte de l'artiste le plus réputé de Paris, Philippe Starck, qui a influencé la métropole comme aucun autre designer.

La relación entre placer, estética y diversión alcanza en París nuevas dimensiones. Las artes culinarias se combinan aquí con espectaculares interiorismos, ya que cocineros y diseñadores tienen una pasión común: desarrollar un estilo propio a partir de la creatividad. Ya sea en Andy Wahloo, Oth Sombath o en el Makassar Lounge & Restaurant, las influencias cosmopolitas se amalgaman con la elegancia intrínsecamente parisina y se integran en el interior de los templos del buen comer. Numerosos hoteles, restaurantes, bares, showrooms y locales comerciales llevan el sello de prestigiosos diseñadores, y afán de superación da lugar a nuevas y sorprendentes cumbres del ingenio creativo, como la antigua piscina de Saint-Germain-des Prés, reconvertida en tienda insignia de Hermès, o el viejo Renard, que ha dado lugar a un popular restaurante-karaoke. En hostelería, los diseñadores han sabido integrar el signo de los tiempos en la concepción de las habitaciones. Philippe Starck, posiblemente el más famoso de los creadores parisinos, destaca a este respecto en la metrópolis como ningún otro.

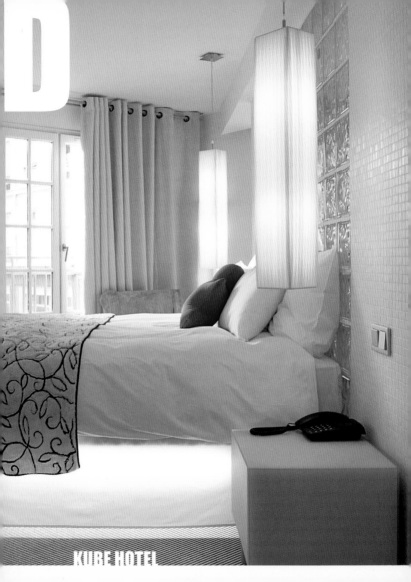

KUBE HOTEL

D

Anyone who wants to spend a night in a unique, avant-garde boutique hotel off the boulevards, has come to the right place in Kube. Behind its classic 19th century façade guests can expect to find an unusual interior by designers Raymond Morel and Christiane Derory. Dominating element is the cube, whose form is everywhere to be seen: at reception in the form of a glazed die, in the 41 rooms and in the Ice Kube Bar where guests can enjoy a drink at minus temperatures.

Wer in einem besonderen Avantgarde-Boutique-Hotel abseits der Prachtstraßen nächtigen möchte, ist im Kube genau richtig. Hinter einer klassischen Fassade aus dem 19. Jahrhundert erwartet den Gast ein ungewöhnliches Interieur der Designer Raymond Morel und Christiane Derory. Alles beherrschendes Element ist der Kubus, dessen Form es überall zu entdecken gibt: an der Rezeption in Form eines gläsernen Würfels, in den 41 Zimmern oder in der Ice Kube Bar, wo man seinen Drink bei Minusgraden genießt.

Pour ceux qui veulent passer la nuit dans un hôtel-boutique avant-gardiste loin des grands boulevards, le Kube est tout simplement l'endroit parfait. Derrière la façade du XIXe siècle, on découvre un intérieur insolite décoré par Raymond Morel et Christiane Derory. Le cube est présent partout : à la réception, qui est elle-même composée d'un cube de verre, dans les 41 chambres ou bien à l'Ice Kube Bar, où l'on peut déguster des cocktails par des températures négatives.

Quien desee pernoctar en un vanguardista hotel alejado de las grandes avenidas, encontrará en el Kube lo que busca. Tras una fachada clásica del siglo XIX se abre al huésped un extraordinario interior diseñado por Raymond Morel y Christiane Derory. El elemento predominante en el concepto es el cubo, omnipresente en el establecimiento: en la recepción, dominada por un cubo vidriado, en las 41 habitaciones y en el Ice Kube Bar, en el que degustar una bebida a temperaturas gélidas.

KUBE HOTEL

1–5, passage Ruelle // Montmartre
Tel.: +33 (0)1 42 05 20 00
www.muranoresort.com

Métro La Chapelle

In Mama Shelter, boredom is never on the menu as there is something to read everywhere you turn: on the floor, ceiling, and walls, on the mirrors, even in the lift. This designer hotel, fitted out by Philippe Starck, is located near the famous Père Lachaise cemetery and is noticeable for its colorful mix of styles which, when bathed in a warm, low light, produce a joyful, feel-good ambience. A particular service offered by this hotel is the free use of large iMac computers.

Langeweile kommt im Mama Shelter sicher nicht auf, denn überall gibt es etwas zu lesen: auf Fußböden, an Decken und Wänden, an Spiegeln und sogar im Aufzug. Das von Philippe Starck ausgestattete Design-Hotel liegt in der Nähe des Prominenten-Friedhofs Père Lachaise und zeichnet sich durch einen bunten Stilmix aus, der, in ein warmes, schummriges Licht getaucht, eine fröhliche Wohlfühlatmosphäre erzeugt. Als besonderen Service bietet das Hotel in allen Zimmern große iMacs zur freien Verfügung.

Chez Mama Shelter, vous ne risquez pas de vous ennuyer car partout vous trouverez quelque chose à lire : sur le plancher, au plafond, sur les murs, les miroirs et même dans l'ascenseur. Décoré par Philippe Starck, cet hôtel design situé à proximité du cimetière du Père Lachaise se distingue par une association osée de styles et une lumière tamisée créant une atmosphère de bien-être. Dans toutes les chambres, l'hôtel met des iMacs à disposition de ses clients.

El aburrimiento no es una opción en Mama Shelter, ya que las posibilidades de lectura son omnipresentes: en los suelos, en las paredes y techos, en los espejos e incluso en el ascensor. El hotel de diseño acondicionado por Philippe Starck se encuentra en las proximidades del cementerio de Père Lachaise y se caracteriza por una festiva mezcla de estilos que, sumida en una cálida luz, genera una atmósfera acogedora y confortable. Una curiosidad: cada habitación dispone de un iMac.

MAMA SHELTER

109, rue de Bagnolet // Porte de Bagnolet
Tel.: +33 (0)1 43 48 48 48
www.mamashelter.com

Métro Gambetta or Porte de Bagnolet

HÔTEL GABRIEL PARIS MARAIS

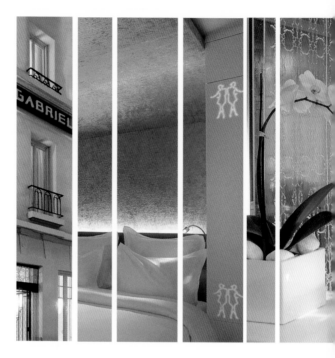

HÔTEL GABRIEL PARIS MARAIS

25, rue du Grand Prieuré // République
Tel.: +33 (0)1 47 00 13 38
www.hotel-gabriel-paris.com

Métro Oberkampf or République

Well-being and health are the focus of this boutique-hotel. The '30s building lies at the heart of the Marais district and was renovated in 2009 by Axel Schoenert Architectes Associés (ASAA). Art deco elements are elegantly combined with the softly colored, light, and modern interior, offering true relaxation and pure detox. The positive effect of this "Zen" atmosphere will not go unappreciated, particularly by those more stressed visitors.

Wohlbefinden und Gesundheit stehen im Mittelpunkt dieses Boutique-Hotels. Das Gebäude aus den 30er Jahren liegt im Herzen des Marais-Viertels und wurde 2009 von Axel Schoenert Architectes Associés (ASAA) renoviert. Elemente des Art déco sind elegant mit einem in sanften Farben und Licht gehaltenen, modernen Interieur verbunden, das ganz der Entspannung und Detox-Wellness dient. Der positiven Wirkung dieser „Zen"-Atmosphäre wird sich der gestresste Gast sicherlich nicht entziehen können.

Cet hôtel-boutique est entièrement dédié au bien-être et à la santé. L'édifice des années 30, qui se situe au cœur du quartier du Marais, a été rénové en 2009 par Axel Schoenert Architectes Associés (ASAA). Les éléments Art déco se marient à merveille avec l'intérieur moderne aux couleurs tendres et éclairages doux qui respire la détente et le bien-être détox. Les clients qui arrivent stressés à l'hôtel seront charmés par les effets positifs de cette atmosphère « zen ».

El confort y la salud son conceptos clave en este hotel boutique. El edificio data de la década de 1930 y se encuentra en el corazón mismo del Marais; en 2009 fue renovado por Axel Schoenert Architectes Associés (ASAA). Los elementos Art déco se engarzan con elegancia en el moderno interior de luces y colores suaves, y el conjunto invita a la relajación y regeneración de fuerzas. A buen seguro, el huésped estresado no sabrá escapar a los efectos positivos de esta atmósfera "zen".

LA CANTINE DU FAUBOURG

105, rue du Faubourg Saint-Honoré // Champs-Élysées
Tel.: +33 (0)1 42 56 22 22
www.lacantine.com

Daily 11 am to 4 am
Métro Saint-Philippe du Roule

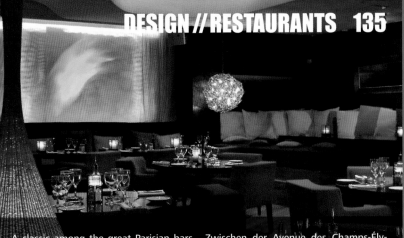

A classic among the great Parisian bars and restaurants is to be found between Avenue des Champs-Élysées, Boulevard Haussmann, and Avenue Franklin D. Roosevelt: the glamorous Cantine du Faubourg. Interior design, colors, paintings, and music will already enchant guests as they step in. A system of screens, curtains, and light and sound technology allow the designers of Axel Schoenert Architectes Associés to make this fixed room float and change.

Zwischen der Avenue des Champs-Élysées, dem Boulevard Haussmann und der Avenue Franklin D. Roosevelt befindet sich der Klassiker unter den besten Bars und Restaurants von Paris: die glamouröse La Cantine du Faubourg. Schon beim Betreten verzaubern Innendesign, Farben, Bilder und Musik den Gast. Durch ein System aus Leinwänden, Vorhängen, Licht- und Soundtechnik gelingt es den Designern von Axel Schoenert Architectes Associés, einen festen Raum schweben und sich verändern zu lassen.

À la croisée des Champs-Élysées, du boulevard Haussmann et de l'avenue Franklin D. Roosevelt, se trouve une véritable institution parmi les meilleurs bars et restaurants de Paris : la glamoureuse Cantine du Faubourg. On est de suite envoûté par sa décoration intérieure, ses couleurs, ses tableaux et sa musique. Par un subtil jeu d'écrans, rideaux, lumières et musiques, les designers de l'architecte Axel Schoenert parviennent à faire onduler la pièce et la métamorphoser.

Entre la avenida de los Campos Elíseos, el Boulevard Haussmann y la avenida Franklin D. Roosevelt se encuentra el más clásico de los mejores restaurantes y bars parisinos: La Cantine du Faubourg. Desde la entrada misma, el interiorismo, los colores, las imágenes y la música seducen al comensal. Un sistema de pantallas, cortinas luces y sonido concebido por los diseñadores de Axel Schoenert Architectes Associés permite que un espacio en principio fijo devenga etéreo y cambiante.

MAKASSAR LOUNGE & RESTAURANT

39, avenue de Wagram // Champs-Élysées
Tel.: +33 (0)1 55 37 55 57
www.makassarlounge.fr

Daily 7 pm to 2 am
Métro Ternes

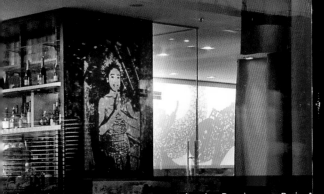

The Makassar Lounge & Restaurant is located in the Renaissance Paris Arc de Triomphe hotel. South-east Asian ebony, as was so popular with the art deco designers of the '20s, and the port of Makassar, from which the wood was shipped to Paris, are what gives the place its name. Designer Henry Chebaane and ERA Architecture play with far Eastern references such as buffalo leather, dark wooden floorings, silver leather curtains, shadow theatre, film, and fashion.

Im Renaissance Paris Arc de Triomphe Hotel befindet sich das Makassar Lounge & Restaurant. Ebenholz aus Südostasien, wie es bereits in den 20er Jahren bei Art déco-Designern beliebt war und der Hafen Makassar, von dem aus es nach Paris verschifft wurde, sind die Namensgeber. Designer Henry Chebaane und ERA Architecture spielten beim Interieur mit fernöstlichen Andeutungen in Form von Büffelleder, dunklen Holzböden, silbernen Ledervorhängen, Schattentheater, Film und Fashion.

Au sein de l'Hôtel Renaissance Paris Arc de Triomphe se niche le Makassar Lounge & Restaurant. Son nom vient du bois d'ébène, très apprécié par les designers Art déco des années 20, qui était transporté vers Paris depuis le port de Makassar. Le designer Henry Chebaane et ERA Architecture apportent des notes d'Extrême Orient par le biais du cuir de buffle, des planchers en bois foncé, des rideaux de cuir coloris argent, des ombres chinoises, du cinéma et de la mode.

En el hotel Renaissance Paris Arc de Triomphe se halla el Makassar Lounge & Restaurant. Su nombre viene de la madera de ébano del sudeste asiático, apreciada ya en los años 20 por los diseñadores Art déco, y del puerto Makassar donde se embarcaba hacia París. El diseñador Henry Chebaane y ERA Architecture jugaron en el interior con alusiones al lejano Oriente en forma de cuero de búfalo, suelos de madera oscuros, cortinas de cuero plateadas, sombras chinescas, cine y moda.

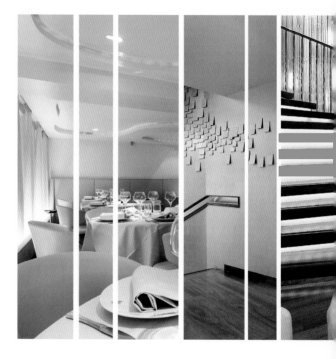

OTH SOMBATH

184, rue du Faubourg Saint-Honoré // Champs-Élysées
Tel.: +33 (0)1 42 56 55 55
www.othsombath.com

Mon–Sat noon to 3 pm, 7 pm to 2 am
Métro Saint-Philippe du Roule

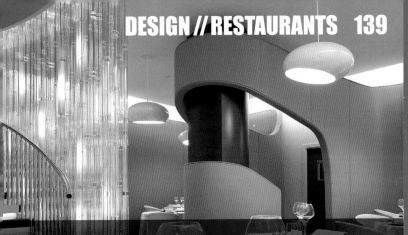

Thai head chef Oth Sombath had this stage for gourmet cuisine erected in the famous Rue du Faubourg Saint-Honoré. The Jouin Manku design team takes its guests, in 4,300 sq. ft., into a Thai universe, placing the bar and three restaurant rooms in a Parisian context. The flowing forms and curved staircase are in perfect harmony with the choice of materials and colors for the interior: dark wood, gold leaf, and light orange and cream tones.

Der thailändische Chefkoch Oth Sombath hat sich an der berühmten Rue du Faubourg Saint-Honoré eine Bühne für seine Gourmetküche errichten lassen. Das Designerteam Jouin Manku entführt die Gäste auf 400 m² in das Universum von Thailand und stellt die Bar sowie die drei Speisesäle in den Pariser Kontext. Fließende Formen und die geschwungene Treppe harmonieren perfekt mit der Material- und Farbauswahl des Interieurs aus dunklem Holz, Blattgold und hellen Orange- und Cremetönen.

Le chef thaïlandais Oth Sombath s'est fait construire une scène à la hauteur de sa cuisine dans la célèbre rue du Faubourg Saint-Honoré. Sur 400 m², l'équipe de designers de Jouin Manku transporte les convives en Thaïlande, tout en gardant un esprit parisien dans les trois salles et au bar. Les formes fluides et l'escalier courbe sont en parfaite harmonie avec les matériaux et couleurs de l'intérieur : le bois foncé, les feuilles d'or et les tons orange et crème.

El chef tailandés Oth Sombath se ha hecho construir en la Rue du Faubourg Saint-Honoré un escenario en el que presentar su cocina para gourmets. El equipo de diseñadores Jouin Manku transporta a los huéspedes en sus 400 m² al universo tailandés y coloca el bar y los tres comedores en el contexto parisino. Las formas fluidas y una escalera ondulada armonizan perfectamente con los materiales y los colores del interior, como madera oscura, pan de oro y vivos tonos anaranjados y crema.

D

Brothers Jean-Louis and Gilbert Costes are known in Paris for their oh-so-trendy hotels and restaurants, and in 2002 their opening of Café Étienne Marcel was once again a real success. They worked on the interior in collaboration with artists Pierre Huygeh and Philippe Parreno, and with the graphic design team M&M Mathias Augustyniak and Michael Amzalag. The result is surprisingly convincing: understatement plus avant-garde with allusions to the decorative style of the late '60s.

Den Brüdern Jean-Louis und Gilbert Costes, in Paris bekannt für besonders trendige Hotels und Restaurants, ist mit dem 2002 eröffneten Café Étienne Marcel wieder einmal ein besonderer Coup gelungen. Für das Interieur haben sie die Künstler Pierre Huygeh und Philippe Parreno mit dem Grafikdesign-Team M&M Mathias Augustyniak und Michael Amzalag zusammengebracht. Das Ergebnis ist überraschend überzeugend: Understatement plus Avantgarde mit Anspielungen an den Dekorstil der späten 60er Jahre.

Les frères Jean-Louis et Gilbert Costes, célèbres à Paris pour leurs hôtels et restaurants à la mode, ont à nouveau réussi leur coup avec l'ouverture en 2002 du Café Étienne Marcel. Les artistes Pierre Huygeh et Philippe Parreno se sont chargés de l'architecture intérieure en collaboration avec l'équipe de design graphique M&M Mathias Augustyniak et Michael Amzalag. Le résultat est impressionnant : minimaliste et avant-gardiste, avec des rappels du style fin années 60.

Los hermanos Jean-Louis y Gilbert Costes, conocidos en París por hoteles y restaurantes especialmente a la moda, volvieron a acertar en 2002 con la apertura del Café Étienne Marcel. El interior es resultado de la colaboración entre los artistas Pierre Huygeh y Philippe Parreno y el equipo diseño gráfico de M&M Mathias Augustyniak y Michael Amzalag. El resultado: un espacio inusitadamente conseguido, sutil y vanguardista con alusiones al estilo decorativo de finales de los años 60.

CAFÉ ÉTIENNE MARCEL

34, rue Étienne Marcel // Étienne Marcel
Tel.: +33 (0)1 45 08 01 03

Daily 9 am to midnight
Métro Étienne Marcel

Philippe Starck, together with Laurent Taïeb, has created a restaurant of refined cuisine on the two uppermost floors of the Kenzo company headquarters. Beneath the imposing glass dome, and its atmospheric light design, visitors can expect a Geisha-inspired interior with materials as varied as leather, plush, and plexiglass. Spectacular views across the Seine, Pont Neuf and Île de la Cité are a calming treat for tired eyes.

In den beiden obersten Stockwerken der Kenzo-Firmenzentrale gestaltete Philippe Starck gemeinsam mit Laurent Taïeb ein Restaurant der gehobenen Küche. Unter einer imposanten Glaskuppel und in atmosphärischem Lichtdesign erwartet die Besucher ein von Geishas inspiriertes Innendesign mit so unterschiedlichen Materialien wie Leder, Plüsch und Plexiglas. Wer seinen Augen eine beruhigende Pause gönnen möchte, genießt die spektakuläre Aussicht über Seine, Pont Neuf und Île de la Cité.

Aux deux derniers étages du siège de Kenzo se situe un restaurant de haute gastronomie décoré par Philippe Starck, en collaboration avec Laurent Taïeb. Sous l'imposante coupole de verre et dans une ambiance feutrée, les visiteurs trouveront une décoration intérieure qui est inspirée des geishas et arbore cuir, matière peluche et plexiglas. Pour reposer ses yeux, rien de tel que la vue spectaculaire sur la Seine, le Pont Neuf et l'Île de la Cité.

Philippe Starck dio forma junto a Laurent Taïeb a un restaurante de alta cocina en los dos pisos superiores de la casa central de Kenzo. Bajo una imponente cúpula de cristal y con una iluminación de diseño atmosférico, el huésped accede a un interior inspirado en las geishas que combina materiales tan diversos como cuero, felpa y plexiglás. Quien desee dar una relajante pausa a sus ojos, puede disfrutar de la espectacular vista del Sena, el Pont Neuf y la Isla de la Île de la Cité.

KONG BAR RESTAURANT

1, rue du Pont Neuf // Hôtel de Ville
Tel.: +33 (0)1 40 39 09 00
www.kong.fr

Daily 10.30 am to 2 am
Métro Pont Neuf

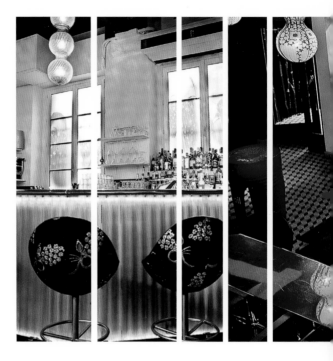

ANDY WAHLOO

69, rue des Gravilliers // Le Marais
Tel.: +33 (0)1 42 71 20 38
www.andywahloo-bar.com

Tue–Sat 6 pm to 2 am
Métro Arts et Métiers

The Andy Wahloo bar takes pride in the unique "bazaar" ambience that makes it such a unique location. A colorful and creative interior in a Moroccan '70s style is combined with lacquered pails redesigned to function as seats, signs as tables, and Arabian lanterns and cushions. Alternating live DJs ensure that the musical ambiance is perfectly in tune. Owner Mourad Mazouz designed the interior in close cooperation with the designer Annabel Karim Kassar.

Die Bar Andy Wahloo kultiviert eine spezielle Bazarstimmung, die sie zu einem ungewöhnlichen Szeneort macht. Ein buntes und kreatives Interieur im Stil Marokkos der 70er Jahre ist kombiniert mit zu Sitzen umfunktionierten Lackeimern, Schildern als Tischen sowie arabischen Laternen und Kissen. Wechselnde Live-DJs sorgen für das dazu passende musikalische Ambiente. Das Innendesign hat der Inhaber Mourad Mazouz in enger Zusammenarbeit mit der Designerin Annabel Karim Kassar umgesetzt.

Le bar Andy Wahloo cultive une ambiance de bazar particulière rendant cet endroit insolite. L'intérieur coloré et créatif au style marocain des années 70 est associé à des seaux de peinture convertis en sièges, des panneaux en guise de tables ainsi que des lampes et coussins orientaux. Différents DJs se relaient pour assurer l'ambiance musicale. L'intérieur a été réalisé par le maître des lieux, Mourad Mazouz, en étroite collaboration avec la designer Annabel Karim Kassar.

El bar Andy Wahloo apuesta por un aire de bazar que hace de él un espacio muy peculiar en la noche parisina. Un interior colorista y original inspirado en el Marruecos de los años 70 combina cubos de pintura reconvertidos en taburetes, señales de tráfico por mesas y lámparas y cojines árabes. Una sucesión de DJs se encarga de la ambientación musical. El diseño del interior es obra del propietario Mourad Mazouz, en colaboración con la diseñadora Annabel Karim Kassar.

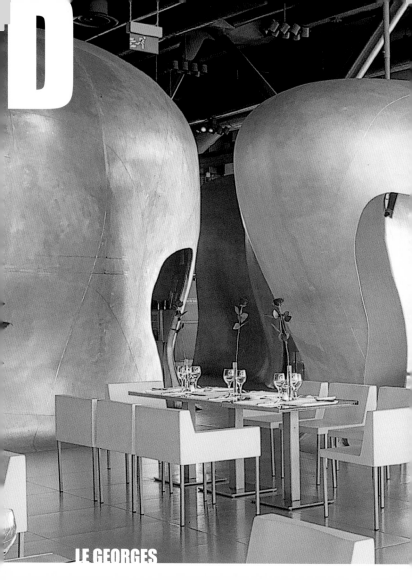

D

LE GEORGES

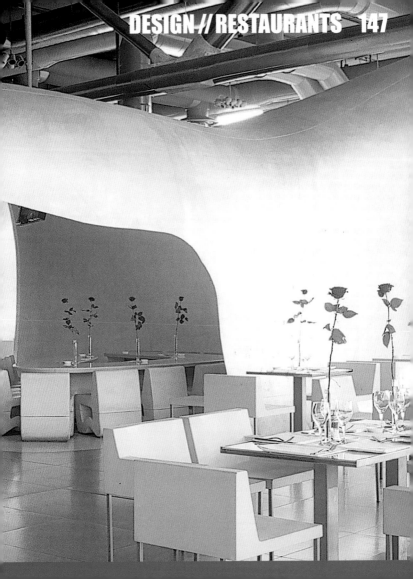

A visit to Le Georges after Centre Pompidou should be on everybody's list. Fusion cuisine is set against the avant-garde interior by Dominique Jakob and Brendan MacFarlane. The roof terrace is perhaps the most beautiful in Paris, with spectacular views of Notre-Dame and Montmartre. The regular crowd here is chic and trendy, and students also like to come for coffee. When the museum closes, simply take the lift directly up to the sixth floor.

Nach dem Besuch des Centre Pompidou gehört auch das Le Georges zum Pflichtprogramm. Hier gibt es Fusion-Küche in avantgardistischem Innendesign von Dominique Jakob und Brendan MacFarlane. Die Dachterrasse gilt als die schönste in Paris mit einer spektakulären Sicht auf Notre-Dame und Montmartre. Das Stammpublikum ist schick und trendig, aber auch Studenten kommen gerne auf einen Kaffee hierher. Nach Museumsschluss fährt man direkt mit dem Aufzug in den sechsten Stock.

Après une visite du Centre Pompidou, Le Georges est un passage obligé. On y déguste une cuisine fusion dans un design intérieur de Dominique Jakob et Brendan MacFarlane. Avec sa vue spectaculaire sur Notre-Dame et Montmartre, la terrasse sur le toit est l'une des plus belles de Paris. La clientèle est plutôt chic et tendance mais les étudiants viennent aussi souvent y prendre un café. Après la fermeture du musée, on accède directement au sixième étage avec l'ascenseur.

Tras una visita al Centro Pompidou, Le Georges es un local de parada obligada. Ofrece cocina fusión en un interior de diseño vanguardista de Dominique Jakob y Brendan MacFarlane. La azotea está considerada la más bonita de París, con unas vistas espectaculares de Notre-Dame y Montmartre. El público habitua les elegante y muy a la moda, pero también acuden estudiantes a tomar un café. Cuando el museo cierra sus puertas, el ascensor sube directamente hasta la sexta planta.

LE GEORGES

19, rue Beaubourg, Place Georges Pompidou // Le Marais
Tel.: +33 (0)1 44 78 47 99
www.restaurantgeorges-costes.com

Daily 11 am to 2 am
Métro Rambuteau

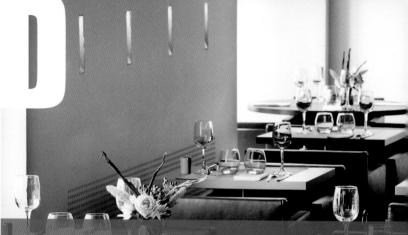

The appeal of the Saut du Loup restaurant lies firstly in its privileged location in the Louvre's Musée des Arts Décoratifs. Yet for lovers of aesthetics it is the interior decor that is most worth seeing. This bears the signature of the stage designer Philippe Boisselier, who has created a minimalist composition of black and white styling, harmonious light effects, and elegant, modern furniture. Outside, the large terrace with view onto the Tuileries—a masterpiece of French garden design—is sure to impress.

Der Reiz des Restaurants Le Saut du Loup liegt zum einen an seiner privilegierten Lage im Musée des Arts Décoratifs am Louvre. Für Ästheten ist aber vor allem das Innendesign sehenswert. Es trägt die Handschrift des Bühnenbildners Philippe Boisselier, der eine minimalistische Komposition aus schwarz-weißem Styling, stimmiger Lichtregie und elegant-modernem Mobiliar geschaffen hat. Draußen beeindruckt die riesige Terrasse mit Blick auf die Tuilerien, ein Meisterwerk französischer Gartenkunst.

Le charme du restaurant Le Saut du Loup est tout d'abord lié à sa situation privilégiée dans le Musée des Arts Décoratifs du Louvre. Les esthètes sont quant à eux surtout attirés par le design intérieur qui porte la griffe du décorateur Philippe Boisselier : une composition minimaliste en noir et blanc, une lumière harmonieuse et un mobilier élégant et moderne. À l'extérieur, l'immense terrasse offre une vue superbe sur les Tuileries, chef d'œuvre du jardin à la française.

El restaurante Le Saut du Loup debe parte de su atractivo a su privilegiada ubicación en el Musée des Arts Décoratifs du Louvre. Sin embargo, los estetas valoran sobre todo su diseño interior. Lo firma el escenógrafo Philippe Boisselier, que ha creado una composición minimalista de estilo blanco y negro, armoniosa iluminación y mobiliario moderno y elegante. Impresiona la enorme terraza con vistas a las Tullerías, una obra de arte de la jardinería francesa.

LE SAUT DU LOUP

107, rue de Rivoli // Louvre
Tel.: +33 (0)1 42 25 49 55
www.lesautduloup.com

Daily noon to 2 am
Métro Pyramides

On Avenue Montaigne, famed for haute couture, you'll find the Maison Blanche restaurant on the roof of the Théâtre des Champs-Élysées. The clue is in the name: white dominates the whole of the interior, bearing the signature of Philippe Starck's pupil Imaad Rahmouni. Depending on your mood you can choose a seat in a white satin-clad alcove or at a table behind the enormous window front to enjoy a breathtaking view of Paris.

Auf der für Haute Couture berühmten Avenue Montaigne befindet sich auf dem Dach des Théâtre des Champs-Élysées das Restaurant Maison Blanche. Und der Name ist Programm: Weiß dominiert die gesamte Innenarchitektur, die die Handschrift von Philippe-Starck-Schüler Imaad Rahmouni trägt. Je nach Stimmung kann der Gast in einer mit weißer Seide ausgekleideten Nische Platz nehmen oder an einem Tisch hinter der riesigen Fensterfront einen atemberaubenden Blick über Paris genießen.

Situé sur l'avenue Montaigne célèbre pour sa haute couture, sur le toit du Théâtre des Champs-Élysées, on découvre le Restaurant Maison Blanche. Son nom en dit long : le blanc domine l'architecture intérieure qui porte la signature de l'élève de Philippe Starck, Imaad Rahmouni. Le client a le choix selon son humeur entre une alcôve drapée de soie blanche ou une table située devant une grande baie vitrée offrant une vue imprenable sur Paris.

En la Avenue Montaigne, famosa por la alta costura, el restaurante Maison Blanche se halla sobre el tejado del Théâtre des Champs-Élysées. El nombre lo dice todo: el blanco domina por completo la arquitectura interior, firmada por Imaad Rahmouni, alumno de Philippe Starck. Según el estado de ánimo, el huésped puede acomodarse en un nicho revestido con seda blanca, o disfrutar de las impresionantes vistas de París desde una mesa tras la enorme fachada de vidrio.

LA MAISON BLANCHE

15, avenue Montaigne // Champs-Élysées
Tel.: +33 (0)1 47 23 55 99
www.maison-blanche.fr

Mon–Thu noon to 2 pm, 8 pm to 11 pm
Fri–Sat 8 pm to 5 am
Métro Franklin D. Roosevelt or Alma / Marceau

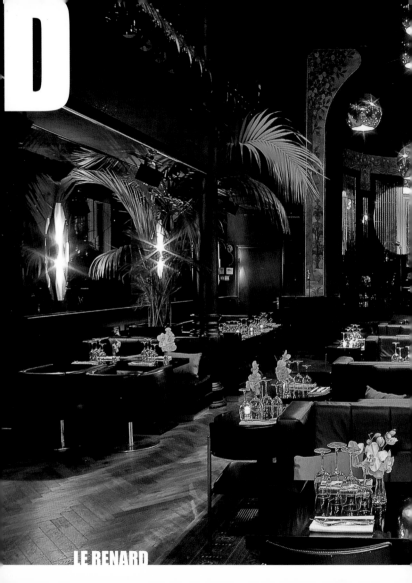

D

LE RENARD

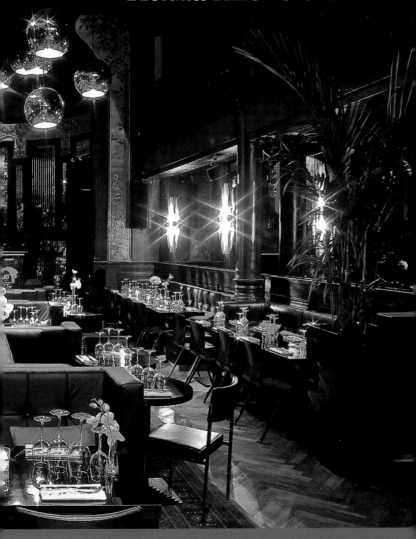

LE RENARD

12, rue du Renard // Le Marais
Tel.: +33 (0)1 42 71 86 27
www.renardrenard.com

Tue–Sat 8.30 pm to 4 am
Métro Hôtel de Ville

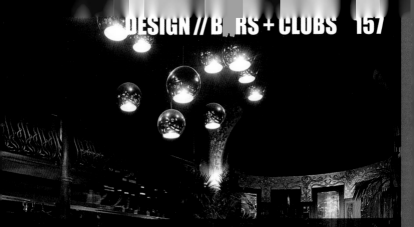

Back in 2009, the architect Franklin Azzi created a new, trendy karaoke restaurant for 130 customers using the rooms of the Théâtre du Renard. Inspired by the Sunday night karaoke sessions at Cipriani, Downtown New York, this former theatre hall is resplendent in its fine leather, lacquer, and wood. Azzi has succeeded, with his interior, in producing a surprising effect balanced somewhere between East and West.

Der Architekt Franklin Azzi hat aus den Räumen des Théâtre du Renard im Jahr 2009 ein neues Szene-Karaoke-Restaurant für 130 Gäste kreiert. Inspiriert von den Sonntag-Nacht-Karaoke-Sessions in Cipriani Downtown New York erstrahlt der alte Theatersaal in kunstvollem Glanz aus edlem Leder, Lack und Holz. Azzi erzeugt mit seinem Interior Design eine überraschende Wirkung, angesiedelt zwischen Orient und Okzident.

L'architecte Franklin Azzi a transformé en 2009 le Théâtre du Renard en un restaurant karaoké branché de 130 couverts. Inspirée des soirées karaoké du dimanche soir chez Cipriani dans le quartier new-yorkais de Downtown, la salle de théâtre brille de par ses cuirs, ses peintures et ses boiseries nobles. Grâce à sa décoration intérieure, Azzi a réussi le pari de combiner à merveille l'Orient et l'Occident.

El arquitecto Franklin Azzi creó en 2009 un popular restaurante-karaoke a partir del edificio del antiguo Théâtre du Renard. Inspirada en las sesiones de karaoke dominicales del neoyorquino Cipriani Downtown, la vieja sala ha recuperado el viejo esplendor y se abre al público en esmaltados y maderas y cueros nobles. El interiorismo de Azzi consigue generar un sorprendente efecto en el que se conjugan Oriente y Occidente.

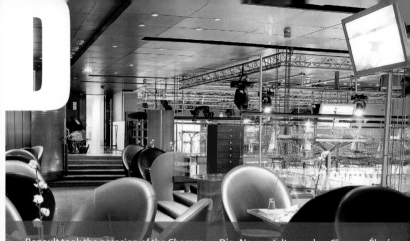

Renault took the occasion of the Champs-Élysées' 1999 reorganization to give its long standing address its own make-over. This modern and prestigious flagship showroom opened in 2000, and since then more than three million visitors per year have strolled through the Renault workshop, which boasts a good affiliated restaurant and bar. Franck Hammoutène kept the architecture and design low key: very light and spacious with plenty of glass, wood, and aluminum.

Die Neugestaltung der Champs-Élysées im Jahr 1999 nahm Renault zum Anlass, auch seiner altehrwürdigen Adresse ein neues Gesicht zu geben. 2000 eröffnete dann der moderne, repräsentative Flagship-Showroom. Seitdem flanieren mehr als drei Millionen Besucher jährlich durch das Atelier Renault, dem ein gutes Restaurant und eine Bar angegliedert sind. Franck Hammoutène hat die Architektur und das Design zurückhaltend, sehr hell und weiträumig mit viel Glas, Holz und Aluminium gestaltet.

En 1999, Renault a profité du réaménagement des Champs-Élysées pour donner un nouveau visage à son adresse historique. Le show room moderne a ouvert ses portes en 2000. Depuis, trois millions de visiteurs franchissent chaque année les portes de l'Atelier Renault, auquel un restaurant et un bar se sont ajoutés. Franck Hammoutène a choisi une architecture et un design sobre, vaste et très lumineux avec beaucoup de verre, de bois et d'aluminium.

Renault aprovechó la remodelación de los Champs-Élysées en 1999 para dar un lavado de cara a su venerable sede parisina. En 2000 inauguró la moderna sede central de la marca. Desde entonces, más de tres millones de visitantes se acercan cada año al Atelier Renault, que cuenta también con un buen restaurante y un bar. Franck Hammoutène proyectó la arquitectura y el diseño de forma discreta, muy luminosa y amplia, empleando mucho cristal, madera y aluminio.

L'ATELIER RENAULT

53, avenue des Champs-Élysées // Champs-Élysées
Tel.: +33 (0)8 11 88 28 11
www.atelier.renault.com

Sun–Thu 10.30 am to 12.30 am
Fri–Sat 10.30 am to 2.30 am
Métro Franklin D. Roosevelt

D

C42 CITROËN

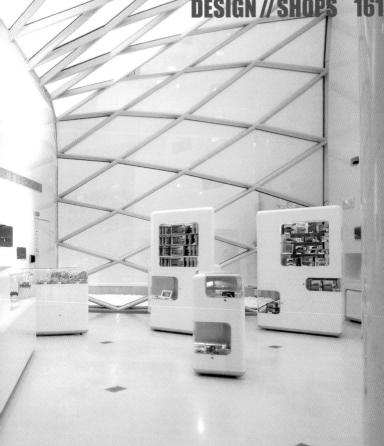

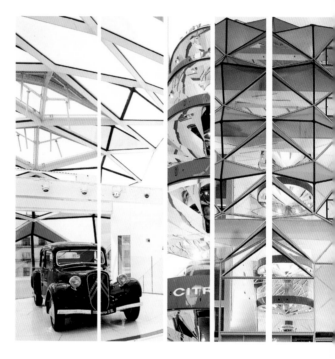

C42 CITROËN

42, avenue des Champs-Élysées // Champs-Élysées
Tel.: +33 (0)8 10 42 42 00
www.citroen.fr

Sun–Wed 10 am to 8 pm, Thu–Sat 10 am to 10 pm
Métro Franklin D. Roosevelt

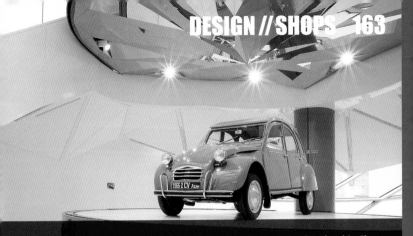

Architect Manuelle Gautrand managed, with the new Citroën flagship show-room on Avenue des Champs-Élysées, to create a glazed temple of presentation whose colorful, accentuated façade is inspired by the classic Citroën double arrow. Inside, new products and anima-tions are displayed on turntables that even reach to the ceiling. The Citroën Lounge and the Citroën Racing areas on the building's upper floors provide relax-ation and thrill.

Mit dem neuen Citroën Flagship-Show-room an der Avenue des Champs-Élysées hat die Architektin Manuelle Gautrand einen gläsernen Präsentationstempel geschaffen, dessen farbig akzentuierte Fassadengestaltung von dem für Citroën typischen Doppelwinkel inspiriert ist. Im Inneren ziehen sich Drehscheiben bis unter die Decke, auf denen neue Produkte und Animationen präsentiert werden. Auf der obersten Etage des Gebäudes sor-gen die Citroën Lounge und das Citroën Racing für Entspannung und Nervenkitzel.

En créant le nouveau show room Citroën des Champs-Élysées, l'architecte Manuelle Gautrand a réalisé un écrin de verre, dont la façade aux accents colorés est inspirée des deux chevrons emblématiques de Citroën. À l'intérieur et jusqu'au plafond, on retrouve des plaques tournantes sur les-quelles les produits et diverses animations de la marque sont présentés. Au dernier étage du bâtiment, le Citroën Lounge et le Citroën Racing proposent détente et sen-sations fortes.

Con la nueva sede central de la marca en la Avenue des Champs-Élysées, la arquitecta Manuelle Gautrand ha creado un templo representativo de cristal. Diversas notas de color definen el diseño de la fachada, claramente inspirada en el doble ángulo de la insignia Citroën. En el interior, plataformas giratorias que llegan hasta el techo presentan nuevos produc-tos y animaciones. En la planta superior del edificio, el Citroën Lounge y el Citroën Racing ofrecen relajación y emoción.

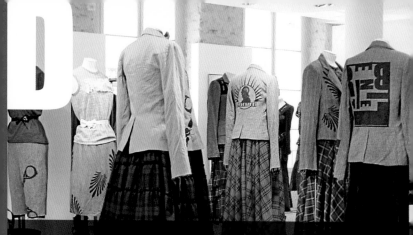

Colette, a concept store institution in Paris, is where you'll find the trends of tomorrow. The luxury department store on Rue Saint-Honoré was designed in 1998 by Arnaud Montigny, and completely renovated in 2008 following the plans of Masamichi Katayama. All of Paris rummages through over 86,000 sq. ft. of fashion, art, literature, photography, perfume, and now even groceries. The Water Bar in the basement, with over 100 different brands of water, invites you to take a break from the boutique.

Bei Colette gibt es die Trends von morgen. Als Concept-Store ist es in Paris eine Institution. Das Shop-Design des Luxuskaufhauses an der Rue Saint-Honoré wurde 1998 von Designer Arnaud Montigny entworfen und im Jahr 2008 nach den Entwürfen von Masamichi Katayama komplett renoviert. Auf über 8 000 m² stöbert ganz Paris in Mode, Kunst, Literatur, Fotografie, Parfum und mittlerweile auch Lebensmitteln. Im Untergeschoss lädt die Water Bar mit über 100 Wassermarken zur Shopping-Pause ein.

Chez Colette, on trouve les tendances de demain. Ce concept store est une institution parisienne. Le design de cette boutique de luxe de la rue Saint-Honoré a été conçu en 1998 par Arnaud Montigny puis entièrement réinterprété en 2008 avec le projet de Masamichi Katayama. Voici 8 000 m² dédiés à la mode, l'art, la littérature, la photo, le parfum et même l'alimentaire. Au sous-sol, le Water Bar qui propose plus de 100 marques d'eau différentes, est parfait pour une pause.

En Colette se hallan las tendencias del mañana. Como tienda conceptual es una institución en París. El diseño de la tienda de los almacenes de lujo en la Rue Saint-Honoré fue proyectado en 1998 por Arnaud Montigny y totalmente renovado en 2008 según los planos de Masamichi Katayama. En más de 8 000 m² todo París rebusca entre moda, arte, literatura, fotografía, perfumes y también alimentos. En la planta baja, el Water Bar, con más de 100 marcas de agua, invita a hacer una pausa.

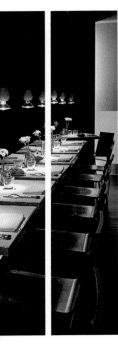

COLETTE

213, rue Saint-Honoré // Louvre
Tel.: +33 (0)1 55 35 33 90
www.colette.fr

Mon–Sat 11 am to 7 pm
Métro Tuileries

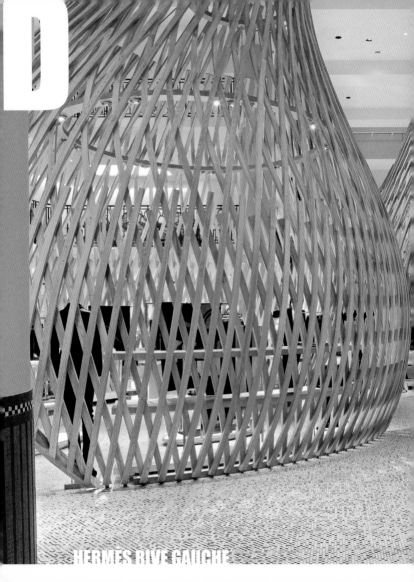

D

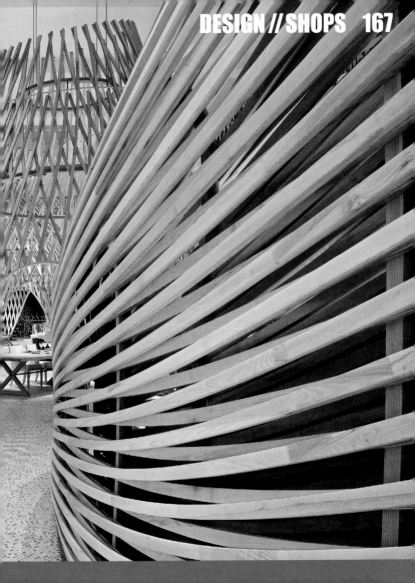

HERMÈS RIVE GAUCHE

17, rue de Sèvres // Saint-Germain-des-Prés
Tel.: +33 (0)1 42 22 80 83
www.hermes.com

Mon–Sat 10.30 am to 7 pm
Métro Sèvres-Babylone

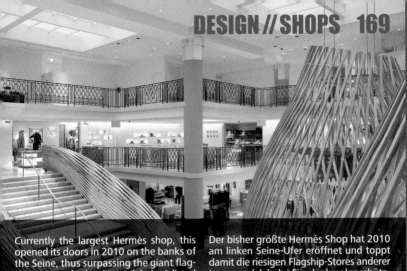

Currently the largest Hermès shop, this opened its doors in 2010 on the banks of the Seine, thus surpassing the giant flagship stores of other luxury labels. A listed swimming pool from the '30s has been transformed into a light 16,000 sq. ft. shop floor. Design agency RDAI managed to integrate art deco elements, such as balustrades and supports, into the shop's design. Particularly eye-catching are the pavilions wreathed with wooden slats and the water-inspired tiled floor.

Der bisher größte Hermès Shop hat 2010 am linken Seine-Ufer eröffnet und toppt damit die riesigen Flagship-Stores anderer Luxusmodelabels. Ein denkmalgeschütztes Schwimmbad aus den 30er Jahren wurde zu einer hellen, 1 500 m² großen Verkaufsfläche umgebaut. Dabei hat die Designagentur RDAI Originalelemente des Art déco-Baus wie Balustraden und Stützen in das Storedesign integriert. Hingucker sind die aus Holzlatten geflochtenen Pavillons und der von Wasser inspirierte Kachelboden.

La plus grande boutique Hermès a ouvert ses portes sur la Rive gauche de la Seine en 2010 et surpasse ainsi toutes les boutiques phare de marques de luxe. Une piscine des années 30 de 1 500 m² classée monument historique a été transformée en espace de vente. L'agence de design RDAI a intégré les éléments Art déco du bâtiment comme les balustrades et piliers au design de la boutique. Il faut absolument voir les huttes de bois tressé et les mosaïques sur le thème de l'eau.

La mayor tienda Hermès hasta hoy abrió en 2010 en la orilla izquierda del Sena, superando a las enormes tiendas de otras marcas. Una piscina de los años 30, monumento histórico protegido, fue transformada en una luminosa superficie comercial de 1 500 m². La agencia RDAI ha integrado en el diseño de la tienda elementos originales Art déco, como balaustradas y soportes. Los pabellones trenzados con taujeles y el suelo de azulejos inspirado en agua son muy llamativos.

RENA
DUM

Rena Dumas was surely one of the greatest female interior designers in the world. The Parisian businesswoman of Greek birth died in 2009 aged 72. After years studying in Paris, Greece, and the US she founded her own agency in 1972: RDAI, Rena Dumas Architecture Intérieure. In 1976, she began her collaboration with Hermès. At the beginning of the '80s the renowned interior designer discovered a second passion: furniture design. The Hermès collapsible furniture collection made from quality wood and leather represented her inimitable style of elegance and practical use. Wife of long-term Hermès director, Jean-Louis Dumas, it was suggested that she should take on decoration for every Hermès shop the world over. Even the latest project—the new flagship store in the former art deco Piscine Lutetia on the rich rive gauche—bears her signature, RDAI believing that the philosophy of its founder still has a place in company policy which the company will continue to follow in the future.

Rena Dumas gehört sicherlich in die Riege der größten Interior-Designerinnen weltweit. Die Pariser Unternehmerin und gebürtige Griechin starb im Jahr 2009 im Alter von 72 Jahren. Nach Studienjahren in Paris, Griechenland und den USA gründete Rena Dumas 1972 ihre Agentur RDAI, Rena Dumas Architecture Intérieure. 1976 begann ihre Zusammenarbeit mit Hermès. Anfang der 80er Jahre entdeckte die renommierte Innenarchitektin ihre zweite Leidenschaft, das Möbeldesign. Die Hermès-Kollektion faltbarer Möbelstücke aus hochwertigem Holz und Leder steht stellvertretend für ihren unnachahmlichen Stil aus Eleganz und praktischem Nutzen. Als Gattin des langjährigen Hermès-Chefs Jean-Louis Dumas lag es nahe, dass sie das Interior-Design aller Hermès-Läden weltweit verantwortete. Auch das jüngste Projekt, der neue Flagship-Store in dem ehemaligen Art déco-Schwimmbad Piscine Lutetia im Nobelviertel Rive Gauche, trägt noch ihre Handschrift, denn für RDAI gehört die Philosophie ihrer Gründerin nach wie vor zur Unternehmensleitlinie, der das Unternehmen auch in Zukunft folgen will.

AS

Rena Dumas compte assurément parmi les designers d'intérieur les plus renommés au monde. Cette femme d'affaire parisienne de nationalité grecque mourut en 2009 à l'âge de 72 ans. Après des études à Paris, en Grèce et aux USA, Rena Dumas créa en 1972 son agence RDAI, Rena Dumas Architecture Intérieure. Sa collaboration avec Hermès débuta en 1976. Au début des années 80, cette architecte d'intérieur renommée découvrit sa seconde passion, le design de meubles. La collection Hermès de meubles pliants en bois et cuir de première qualité reflète son style inimitable alliant l'élégance et le pratique. En tant qu'épouse de Jean-Louis Dumas, qui fut longtemps le patron d'Hermès, elle fut conviée à s'occuper du design intérieur de toutes les boutiques Hermès du monde. Le dernier projet, le magasin phare implanté dans l'ancienne piscine Art déco Lutetia, situé dans le noble quartier Rive Gauche, porte encore sa signature car la philosophie de la fondatrice marque et marquera toujours la ligne directrice de l'entreprise RDAI.

Rena Dumas se cuenta sin duda alguna entre las más importantes diseñadoras de interiores de todo el mundo. La empresaria parisina de origen griego falleció en 2009 a los 72 años de edad. Tras cursar estudios en París, Grecia y Estados Unidos, Rena Dumas fundó en 1972 la agencia RDAI, Rena Dumas Architecture Intérieure. En 1976 comenzó la cooperación con Hermès. A comienzos de los años 80, la reputada interiorista descubrió su segunda pasión: el diseño de mobiliario. La colección Hermès de muebles plegables en cuero y maderas nobles es característica de su inimitable estilo, en el que combinaba elegancia y utilidad práctica. Esposa de Jean-Louis Dumas, quien durante mucho tiempo fuera director de la casa Hermès, no es de extrañar que a ella se le asignase la responsabilidad sobre el interiorismo de los locales de Hermès en todo el mundo. Incluso el proyecto más reciente, el local insignia que ocupa la antigua Piscine Lutetia de estilo Art déco, lleva su sello: la filosofía de la fundadora sigue muy presente en la línea empresarial de RDAI, algo a lo que la agencia desea atenerse también en el futuro.

France's largest underwater attraction takes you on a journey like no other. 43 aquariums, home to 500 species of fish and other water creatures, video walls, and three movie theaters allow you to explore the world's oceans up close. Sharks are just a few feet away, coral reefs unfold in all their beauty, and touch pools invite kids to a hands-on experience. Gripping documentaries focusing on sustainability and environmental protection encourage visitors to get involved.

Frankreichs größte Unterwassererlebniswelt lädt zu einer Reise in die Tiefen der Weltmeere ein. Mit 43 Aquarien, in denen sich 500 Fischarten und andere Wasserwesen tummeln, Videowänden und drei Kinosälen ist die Meereswelt zum Greifen nah. Haifische schwimmen hautnah vorbei, Korallenriffe entfalten ihre Schönheiten und ein Streichelbecken regt Kinder an, mit Fischen auf Tuchfühlung zu gehen. Nachhaltigkeit und Ökologie werden in spannenden Dokumentarfilmen thematisiert.

Le plus grand parc aquatique de France vous invite à découvrir les profondeurs des mers du monde. 43 aquariums, où se prélassent 500 sortes de poissons et autres espèces, films d'animation et trois salles de cinéma vous y accueillent. Dans le tunnel aux requins, vous aurez l'impression de nager à leurs côtés. Les bancs de coraux vous émerveilleront et le bassin caresse fera le bonheur des plus petits. Des documentaires sur l'écologie et le développement durable y sont diffusés.

El mayor centro lúdico marino de Francia invita a adentrarse en las profundidades oceánicas en pleno centro de París. Sus 43 acuarios acogen 500 especies marinas, y los videos murales y las tres salas de cine ponen los secretos del mar al alcance de la mano. Tiburones que nadan a escasos centímetros, arrecifes coralinos en todo su esplendor, acuarios infantiles en los que interactuar con los peces... La sostenibilidad y la ecología se abordan también en interesantísimos documentales.

AQUARIUM DE PARIS – CINÉAQUA

5, avenue Albert de Mun // Trocadéro
Tel.: +33 (0)1 40 69 23 23
www.cineaqua.com

Daily 10 am to 7 pm
Métro Trocadéro or Iéna

ART

Location	N°	page
Cinémathèque Française	1	10
Grand Palais	2	14
Hôtel Biron – Musée Rodin	3	18
Musée du Quai Branly	4	22
Centre Pompidou	5	24
Galerie Celal	6	26
Musée du Louvre	7	30
Fondation Cartier pour l'Art Contemporain	8	32
Galerie Besseiche Lartigue	9	36
Cité de l'Architecture et du Patrimoine	10	38
Guimet – Musée National des Arts Asiatiques	11	42
Musée d'Art Moderne de la Ville de Paris	12	46
Palais de Tokyo	13	48

MAP 175

ARCHITECTURE

page	N°	Location
54	14	Fondation Le Corbusier
58	15	Résidence Universitaire de Croisset
60	16	Opéra Bastille
64	17	France Télévisions
66	18	Parc André Citroën
70	19	Centre de Biotechnologies Biopark
72	20	Passerelle Simone de Beauvoir
76	21	UGC Ciné Cité Bercy
78	22	Passage du Grand Cerf
80	23	Le Cube
82	24	Cœur Défense
84	25	La Grande Arche
88	26	Tour T1
92	27	Cité de la Musique
96	28	Cité des Sciences
100	29	Axa Private Equity
102	30	Place du Marché Saint-Honoré
104	31	Pyramide du Louvre
108	32	Notre-Dame de l'Arche d'Alliance
110	33	École de Commerce Advancia
112	34	Cinetic
114	35	Institut du Monde Arabe

DESIGN

page	N°	Location
124	36	Kube Hotel
128	37	Mama Shelter
130	38	Hôtel Gabriel Paris Marais
134	39	La Cantine du Faubourg
136	40	Makassar Lounge & Restaurant
138	41	Oth Sombath
140	42	Café Étienne Marcel
142	43	Kong Bar Restaurant
144	44	Andy Wahloo
146	45	Le Georges
150	46	Le Saut du Loup
152	47	La Maison Blanche
154	48	Le Renard
158	49	L'Atelier Renault
160	50	C42 Citroën
164	51	Colette
166	52	Hermès Rive Gauche
172	53	Aquarium de Paris – Cinéaqua

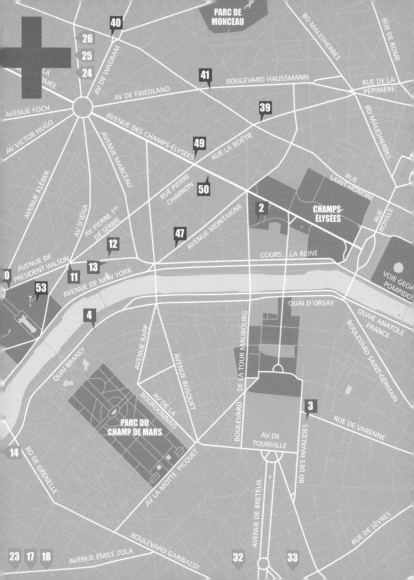

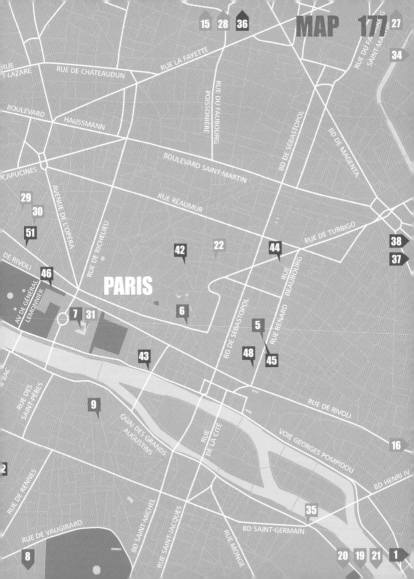

BASTILLE

There was a prison there where the Revolution started, now you could find the Opéra Bastille House, a modern building built to commemorate the Revolution's Bicentennial. Bastille is a historic area once specialized in furniture-making.

BOULOGNE

The Bois de Boulogne is a park located along the western edge of the 16th arrondisement It is full of activities on the weekends, such as biking, jogging, boat rowing. During summer season the bois holds a 3-day weekend party in the month of July.

BOURSE

It is the "theatre district:" a dozen or more can be found in this arrondissement. The Bourse area is also a great place to sample typical Parisian atmosphere: little passageways and arcades full of shops and small cafés.

BUTTES-CHAUMONT

The Buttes-Chaumont is not on the usual tourist circuit and is a great place to explore if you want to see where the locals go to get away from the grind. It is a sweeping romantic-style park whose dramatic bluffs, waterfalls, and rolling green hills provide a welcome sense of space and fresh air to overcrowded Parisians.

CHAMPS-ÉLYSÉES

The Champs-Élysées area is the most popular, the most frequented, and the most chic area of Paris. It starts from the Triumphal Arch and goes along the Concorde Square where you could see the Grand Palais.

LE MARAIS

The oldest neighborhood in Paris. Many 18th century mansions that once housed the most noble families of Paris remain, such as the Hôtel de Rohan and historical museum the Carnavalet. Also known as the gay and trendy area.

MAP 179

LOUVRE

One of the main points of interest for tourists with the famous Louvre Museum, Place de la Concorde, Jardin des Tuileries, and Place Vendôme all at once.

PIGALLE

At the base of Montmartre stairs, famous for its nightlife: bars and clubs. More likely the Red Light District of Paris and host neighborhood of the Moulin Rouge.

MONTMARTRE

The Montmartre hill is full of street artists (painters, sculptors, and poets) who are essentially located on the Tertre Square. It is some kind of a village with its own pace of life, a very picturesque site.

QUAIS DE SEINE

All sorts of books sold in a series of bottle-green boxes, and their 240 booksellers line the banks of the Seine which turns into a beach resort in summer.

OPÉRA

The famous Opéra Garnier is located here and most of all, this district is renowned for its department stores on Boulevard Haussmann: Printemps and the Galeries Lafayette.

QUARTIER LATIN

The area around Saint-Michel and Latin Quarter is full of charm with its narrow pedestrianized streets with cobblestones. It is also called Little Athens because of its Greek inheritance.

RÉPUBLIQUE

The République area houses the most comprehensive contemporary art galleries in town, so this quarter is full of them as well as museums. It is said to be the most magical area of Paris, therefore a nice area to walk around.

SAINT-GERMAIN-DES-PRÉS

The former center of the existentialist movement stayed the ultimate hangout area for bohemians and intellectuals. Trendy upscale boutiques, art galleries, and restaurants can be found throughout this district.

SAINT-OUEN

Saint-Ouen is home to Paris's flea market, the most important concentration of antique dealers and second-hand furniture dealers in the world. It is located in the northern suburbs.

TOUR EIFFEL

Famous yet quiet and typical Parisian neighborhood with its picturesque food market, its cozy restaurants with a warm atmosphere, its colorful boutiques, and typical café terraces.

TROCADÉRO

Site of the Palais Chaillot in the 16th arrondissement. The central terrace between its two wings has been kept clear, forming a perfect frame for the Eiffel Tower beyond. The place is also surrounded by chic restaurants and cafés.

EMERGENCY

Ambulance	Tel.: 15
Police	Tel.: 17
Fire	Tel.: 18

ARRIVAL

BY PLANE

There are two international airports in the city area.
Information: www.aeroportsdeparis.fr

CHARLES DE GAULLE (CDG)

25 km / 15 miles north of downtown Paris. National and international flights.
With RER trains B from Terminal 1 and 2 via Gare du Nord to Châtelet / Les Halles station in the city center (30 mins). With Roissybus from Terminal 1, 2 and 3 to Opéra station (45–60 mins). With Air France coaches to Arc de Triomphe (40 mins)
www.carsairfrance.com
A cab ride to downtown Paris costs approx. 50 euros (40 mins).

PARIS ORLY (ORY)

16 km / 10 miles south of the city center. National and international flights.
With RER line Orlyval to Antony station, then changing to RER line B to Châtelet / Les Halles station in the center (35 mins). With shuttle buses to RER station Pont de Rungis, then change to RER line C to Gare d'Austerlitz (35 mins). With Orlybus to RER station Denfert-Rochereau and then changing to RER line B to Châtelet / Les Halles in the city center (40 mins). With Air France coaches via Gare Montparnasse to the Invalides station (60 mins)
www.carsairfrance.com
A cab ride to downtown Paris costs approx. 35 euros (30 mins).

BY TRAIN

There are six terminal stations in Paris: Gare Saint-Lazare, Gare du Nord, Gare de l'Est, Gare de Lyon, Gare d'Austerlitz and Gare Montparnasse, depending from which direction you are traveling from. All terminal stations have direct access to the Métro or the RER.
Further Railway Information SNCF:
Tel.: +33 (08) 36 35 35 35
www.sncf.fr
Thalys: www.thalys.com

TOURIST INFORMATION

OFFICE DU TOURISME DE PARIS

25, rue des Pyramides 75001 Paris
Tel.: +33 (08) 92 68 30 00
www.parisinfo.com
June–Oct opened daily from 9 am to 7 pm,
Nov–May, Mon–Sat 10 am to 7 pm,
Sun 11 am to 7 pm
Amongst others there are offices at the Gare du Nord station, at Carrousel du Louvre, and at Place du Tertre in Montmartre.

ACCOMMODATION

www.all-paris-apartments.com
Accommodations in Paris (EN)

www.parishotels.com
Hotel search engine and
online reservations (FR, EN)

www.paris-apts.com
Reservation of apartments (EN)

www.paris-sharing.com
Reservation of apartments (FR, EN)

TICKETS

Every Wednesday the event calendars
Pariscope and L'Officiel des Spectacles with
information on movies, theaters, and con-
certs as well as exhibition schedules and
opening hours are published.

TICKET OFFICES

FranceBillet: Tel.: +33 (08) 92 69 21 92
www.otparis.francebillet.com
Fnac: www.fnac.fr
Check Théâtre: www.check-theatre.com
Tickets for theater, opera, and concerts.
Kiosque Théâtre: 15, place de la Madeleine
Discounted last minute theater tickets

GETTING AROUND

PUBLIC TRANSPORTATION
www.ratp.fr RATP
Parisian Métro and RER

TAXI
Taxis Bleus, Tel.: +33 (08) 19 70 10 10
Taxis G7, Tel.: +33 (01) 47 39 47 39

VELIB' (Bicycle self-service)
www.velib.paris.fr
20,600 bicycles over 1,450 stations
(1 every 300 meters) all around the city.
Free the first 30 mins, then 1 to 4 euros
for additional half hours
Tel.: +33 (01) 30 79 79 30

CITY TOURS

SIGHTSEEING BUSES

Several agencies offer guided city tours, the-matic tours and trips, lasting from 1.5 hrs up to 1 day, from 17.50 euros/pers. There are open-topped double-decker buses circulat-ing in the city center every 10–30 mins with the possibility to interrupt the tour at any tourist attraction, day ticket 25 euros/pers., 2-day ticket 28 euros/pers.

Cityrama, 149, rue Saint-Honoré
Tel.: +33 (01) 44 55 61 00
www.cityrama.com

Les Cars Rouges, 17, quai de Grenelle
Tel.: +33 (01) 53 95 39 53
www.carsrouges.com

Paris l'OpenTour, 13, rue Auber
Tel.: +33 (01) 42 66 56 56
www.paris-opentour.com

Paris Vision, 214, rue de Rivoli
Tel.: +33 (01) 42 60 30 01
www.parisvision.com

BICYCLES TOURS

Guided half and full day bicycle tours as well as tours in the evening are organized regularly by:
Paris à Vélo c'est sympa,
22, rue Alphonse-Baudin
Tel.: +33 (01) 48 87 60 01
www.parisvelosympa.com

Paris-Vélo, 2, rue du Fer à Moulin
Tel.: +33 (01) 43 37 59 22
www.paris-velo-rent-a-bike.fr

BOAT TOURS

Seine Tours
Bateaux Parisiens
Tel.: +33 (08) 25 01 01 01
www.bateauxparisiens.com

Compagnie des Bateaux Mouches
Tel.: +33 (01) 42 25 96 10
www.bateauxmouches.com

Vedettes de Paris
Tel.: +33 (01) 44 18 19 50
www.vedettesdeparis.com

Batobus
www.batobus.com

CHANNEL TOURS

Canauxrama
Tel.: +33 (01) 42 39 15 00
www.canauxrama.com

Paris Canal
Tel.: +33 (01) 42 40 96 97
www.pariscanal.com

GUIDED TOURS

Paris Balades
www.parisbalades.com
Tours through Paris with certified
tourist guides. The website gives
an overview of the program and
the organizing companies.

ART & CULTURE

www.journee-du-patrimoine-paris.fr
Journées du Patrimoine Mid Sept, open
day in historical and public buildings

www.legeniedelabastille.net
Artists and galleries in the Bastille
district (FR)

www.monum.fr
Presentation of national architectural
monuments, e.g. Notre-Dame, Arc de
Triomphe, Sainte-Chapelle, Panthéon
(FR, EN)

www.parisbalades.com
Virtual walk through Paris with detailed
information on the districts and architec-
tural monuments (FR)

www.paris-pittoresque.com
The historical Paris with ancient pictures
and engravings (FR)

www.picturalissime.com
Overview over Parisian museums with
links (FR, EN)

www.theatreonline.com
Theater guide (FR)

SPORTS AND LEISURE

www.bercy.fr
Sports calendar and opening hours
of the ice rink in the Palais Omnisports
Paris-Bercy (FR)

www.boisdevincennes.com
Leisure activities in the large Bois
de Vincennes park (FR)

www.disneylandparis.com
Website of the famous amusement
park (EN)

www.pari-roller.com
Exploring Paris on inline skates,
every Fri night for advanced skaters,
every Sun afternoon for beginners
(FR, EN)

GOING OUT

www.parissi.com
Concerts, exhibitions, restaurants,
bars, and clubs (FR)

www.parisvoice.com
Scene guide with tips from the editorial
staff and calendar of events (EN)

EVENTS

FÊTE DE LA MUSIQUE
21st June, Open air concerts of diverse
genres (classical music, jazz and rock, world
music, etc.) in the parks, squares and streets
www.fetedelamusique.culture.fr

BANLIEUES BLEUES
At the beginning of March until the begin-
ning of April, Jazz and world music festival
in the northeastern suburbs
www.banlieuesbleues.org

FÊTE NATIONALE
14th July, the evening before the national
holiday there are public balls, processions
and fireworks, on the 14th there is a huge
military parade on the Champs-Élysées
www.14-juillet.cityvox.com

FESTIVAL D'AUTOMNE
Mid Sept–mid Dec, music,
theater, and movie festival on several
Parisian stages
www.festivalautomne.com

NUIT BLANCHE
At the beginning of Oct, a night full
of cultural events
www.nuitblanche.paris.fr

Cover photo by Martin Nicholas Kunz

ART

p 10–13 (Cinémathèque française) all photos by Stéphane Dabrowski/Cinémathèque française; p 14–17 (Grand Palais) p 16 left by Amélie Dupont, all other by Marc Bertrand/both Paris Tourist Office; p 18–21 (Hôtel Biron – Musée Rodin) all photos by Matthias Just (further credited as maju); p 22–23 (Musée du Quai Branly) all photos by maju; p 24–25 (Centre Pompidou) all photos by maju; p 26–29 (Galerie Celal) all photos courtesy of Galerie Celal; p 30–31 (Musée du Louvre) p 30, 31 left by maju, left middle by Raymond Mesnildrey/Mairie de Paris, all other by Vanessa Berberian; p 32–33 (Fondation Cartier pour l'Art Contemporain) all photos by maju; p 36–37 (Galerie Besseiche Lartigue) all photos courtesy of Galerie Besseiche Lartigue; p 38–41 (Cité de l'Architecture et du Patrimoine) all photos courtesy of Cité de l'Architecture et du Patrimoine; p 42–45 (Guimet – Musée National des Arts Asiatiques) all photos by maju; p 46–47 (Musée d'Art Moderne de la Ville de Paris) p 46 left courtesy of Musée d'Art Moderne, all other by maju; p 48–49 (Palais de Tokyo) all photos by maju

ARCHITECTURE

p 54–57 (Fondation Le Corbusier) p 54–55, 56 right and 57 by maju, all other courtesy of Fondation Le Corbusier/© FLC/VG Bild-Kunst, Bonn 2011; p 58–59 (Résidence Universitaire de Croisset) all photos courtesy of AS. Architecture Studio et P. Tourneboeuf; p 60–63 (Opéra Bastille) all photos by maju; p 64–65 (France Télévisions) p 64 left and 65 by Georges Fessy, p 64 right by Nicolas Borel; p 66–69 (Parc André Citroën) all photos by maju; p 70–71 (Centre de Biotechnologies Biopark) all photos by Andre Morin; p 72–75 (Passerelle Simone de Beauvoir) p 75 middle by Jo Pesendorfer/Feichtinger Architects, p 75 right by Alexandra Douros, all other by Feichtinger Architects; p 76–77 (UGC Ciné Cité Bercy) all photos courtesy of UGC Ciné Cité Bercy; p 78–79 (Passage du Grand Cerf) all photos by Nathalie Grolimund; p 80–81 (Le Cube) p 80 middle by Jean Luc Dolmaire/courtesy of Le Cube, all other courtesy of Le Cube; p 82–83 (Cœur Défense) all photos by Nicolas Borel; p 84–87 (La Grande Arche) all photos by maju; p 88–91 (Tour T1) p 88–89 and p 90 right by Michel Denance, p 90 left courtesy of Tour T1, p 91 by Alexei Naroditsky; p 92–95 (Cité de la Musique) all photos by maju; p 96–99 (Cité

DESIGN

des Sciences) all photos by maju; p 100–101 (Axa Private Equity) all photos by P. Tourneboeuf/Tendance Floue, AS. Architecture-Studio; p 102–103 (Place du Marché Saint-Honoré) all photos by Paris-Sharing.com; p 104–107 (Pyramide du Louvre) p 104–105 by Claire Trochu, all other by maju; p 108–109 (Notre Dame de L'Arche d'Alliance) all photos by AS. Architecture-Studio et Gaston Bergeret; p 110–111 (École de Commerce Advancia) all photos courtesy of AS. Architecture-Sudio; p 112–113 (Cinetic) p 112, 113 left by Michel Denance, 113 right by Alexei Naroditsky; p 114–117 (Institut du Monde Arabe) p 116 left by AS. Architecture Studio et Georges Fessy, all other by maju, Architecture by Jean Nouvel/© VG Bild-Kunst, Bonn 2011

p 124–127 (Kube Hotel) all photos by Roland Bauer; p 128–129 (Mama Shelter) all photos courtesy of Mama Shelter; p 130–133 (Hôtel Gabriel Paris Marais) all photos by Christoph Bielsa; p 134–135 (La Cantine du Faubourg) all photos by Yann Deret; p 136–137 (Makassar Lounge & Restaurant) all photos courtesy of Makassar; p 138–139 (Oth Sombath) all photos courtesy of Oth Sombath; p 140–141 (Café Étienne Marcel) all photos by Roland Bauer; p 142–143 (Kong Bar Restaurant) all photos by Pep Escoda; p 144–145 (Andy Wahloo) all photos courtesy of Andy Wahloo; p 146–149 (Le Georges) all photos by Pep Escoda; p 150–151 (Le Saut du Loup) all photos courtesy of Le Saut du Loup; p 152–153 (La Maison Blanche) p 152 by Pep Escoda, all other courtesy by La Maison Blanche; p 154–157 (Le Renard) all photos by Franklin Azzi Architecture; p 158–159 (L'Atelier Renault) all photos by maju; p 160–163 (C42 Citroën) p 160–161 by Jimmy Cohrssen, all other by Philippe Ruault/both Manuelle Gautrand Architecture; p 164–165 (Colette) all photos courtesy of Colette; p 166–169 (Hermès Rive Gauche) all photos by Michel Denancé; p 172–173 (Aquarium de Paris – Cinéaqua) all photos by maju

A NEW GENERATION

of multimedia travel guides featuring
the ultimate selection of architectural
icons, galleries, museums, stylish
hotels, and shops for cultural and
art conscious travelers.

VISUAL

Immerse yourself into inspiring
locations with photos and videos.

APP FEATURES

Search by categories, districts, or
geo locator; get directions or create
your own tour.

ISBN 978-3-8327-9435-4

BARCELONA
SHANGHAI
TOKYO
SINGAPORE
BEIJING
VIENNA
PARIS
SYDNEY
HONG KONG
MUNICH
ZURICH
NEW YORK
SAO PAULO
AMSTERDAM
MIAMI
MEXICO CITY

LONDON
ROME
EMIRATES
CHICAGO
MILAN
BERLIN

COOL CITIES

**Pocket-size Book,
App for iPhone/iPad/iPod Touch**
www.cool-cities.com

COOL
PARIS

COOL
PARIS

AROUND ME
EXPLORE BY DISTRICT
EXPLORE BY CATEGORY
CITY INFO

teNeues

A NEW GENERATION
of multimedia lifestyle travel guides
featuring the hippest most fashionable
hotels, shops, and dining spots for
cosmopolitan travelers.

VISUAL
Discover the city with tons
of brilliant photos and videos.

APP FEATURES
Search by categories, districts, or geo locator;
get directions or create your own tour.

ISBN 978-3-8327-9489-7

BRUSSELS
VENICE
BANGKOK
MALLORCA+IBIZA
NEW YORK
AMSTERDAM
MIAMI
MEXICO CITY
HAMBURG
LONDON
ROME
MILAN
BERLIN
FRANKFURT
STOCKHOLM
BARCELONA
COPENHAGEN
LOS ANGELES
SHANGHAI
TOKYO
SINGAPORE
VIENNA
BEIJING
COLOGNE
PARIS
HONG KONG
MUNICH

© 2011 Idea & concept by Martin Nicholas Kunz, Lizzy Courage Berlin
Selected, edited and produced by Nathalie Grolimund
Texts by Gerhild Bellinghausen, Sigrid von Fischern, Sabine Scholz
Editorial coordination: Nathalie Grolimund
Executive Photo Editor: David Burghardt, Photo Editor: Maren Haupt
Copy Editor: Sabine Scholz, Dr. Simone Bischoff
Art Director: Lizzy Courage Berlin
Design Assistant: Sonja Oehmke
Imaging and pre-press production: Tridix, Berlin
Translations by RR Communications, Romina Russo
Zoe C Brasier, Romina Russo (English), Samantha Michaux, Élodie Gallois (French)
Pablo Álvarez Ellacuria, Romina Russo (Spanish)

© 2011 teNeues Verlag GmbH + Co. KG, Kempen

teNeues Verlag GmbH + Co. KG
Am Selder 37, 47906 Kempen // Germany
Phone: +49 (0)2152 916-0, Fax: +49 (0)2152 916-111
e-mail: books@teneues.de

Press department: Andrea Rehn
Phone: +49 (0)2152 916-202 // e-mail: arehn@teneues.de

teNeues Digital Media GmbH
Kohlfurter Straße 41–43, 10999 Berlin // Germany
Phone: +49 (0)30 700 77 65-0

teNeues Publishing Company
7 West 18th Street, New York, NY 10011 // USA
Phone: +1 212 627 9090, Fax: +1 212 627 9511

teNeues Publishing UK Ltd.
21 Marlowe Court, Lymer Avenue, London SE19 1LP // UK
Phone: +44 (0)20 8670 7522, Fax: +44 (0)20 8670 7523

teNeues France S.A.R.L.
39, rue des Billets, 18250 Henrichemont // France
Phone: +33 (0)2 4826 9348, Fax: +33 (0)1 7072 3482

www.teneues.com

While we strive for utmost precision in every detail, we cannot be held
responsible for any inaccuracies, nor for any subsequent loss or damage arising.
Bibliographic information published by the Deutsche Nationalbibliothek.
The Deutsche Nationalbibliothek lists this publication in the
Deutsche Nationalbibliografie; detailed bibliographic data are
available in the Internet at http://dnb.d-nb.de.

Printed in the Czech Republic
ISBN: 978-3-8327-9464-4